ENIGMA VARIATIONS

ENIGMA VARIATIONS

Richard Price *and* Sally Price

Harvard University Press Cambridge, Massachusetts London, England 1995

Library of Congress Cataloging-in-Publication Data

Price, Richard, 1941–
Enigma variations / Richard Price and Sally Price.
p. cm.
Includes bibliographical references (p.).
ISBN 0-674-25726-X
I. Price, Sally. II. Title.
PS3566.R543E55 1995
813'.54—dc20

95-1362

To our friends pictured within

Mr. Popescu: Can I ask, is Mr. Martins engaged on a new book?

Holly Martins: Yes, it's called "The Third Man."

Mr. Popescu: A novel, Mr. Martins?

Holly Martins: It's a murder story. I've just started it. It's based on fact.

Mr. Popescu: Are you a slow writer, Mr. Martins?

Holly Martins: Not when I get interested.

Mr. Popescu: I'd say you're doing something pretty dangerous this time.

Holly Martins: Yeah?

Mr. Popescu: Mixing fact and fiction . . .

Holly Martins: Should I make it all fact?

Mr. Popescu: Why no, Mr. Martins. I'd say stick to fiction, straight fiction.

Holly Martins: I'm too far along with the book, Mr. Popescu.

Mr. Popescu: Haven't you ever scrapped a book, Mr. Martins?

Holly Martins: Never.

Mr. Popescu: Pity.

—Dialogue from *The Third Man* (1949),
directed by Orson Welles, filmscript
by Graham Greene and Carol Reed

It wasn't a particularly impressive cortège that filed through the white-washed gates of the Cayenne cemetery. A dozen of his European friends, middle-aged and mainly male, the ruddy-faced *sous-préfet* and the head of the gendarmerie in dress uniform, a few local Creoles, and his housekeeper. We noticed that the director of the museum had chosen not to pay her final respects to Monsieur Lafontaine.

"His generosity," said Yves Revel, wiping away a tear with a flowered hanky. "That's what I won't forget." They'd been through a lot together, the small band of Pied Noir refugees who had arrived in Equatoria by way of Marseille when Algeria fell to the Arabs in '62. In fact, they'd fled from one end of the French tropical empire to another, in a sense merely exchanging *"sales arabes"* for *"sales nègres,"* though a couple of them did pick up a taste for pretty mulattos along the way.

Drawing on the savings they'd smuggled out—inside their shoes, sewn into their trousers—they cleared sufficient space to insert themselves into the slumbering economy of postwar Cayenne: a souvenir shop here, a publishing house there, a cement factory across the creek outside of town. And the best bordello this side of Brazil, with something for every taste provided by a multi-hued staff from six countries.

In those days Cayenne was a town straight out of Somerset Maugham: somnolent in the tropical heat, profoundly colonial, and crawling with varieties of humanity originating from every corner of the globe. A few years before, a French physician had called it "an incoherence of races, a confusion of colors, a Babel of languages, a Babylon of imported vices." And a visiting anthropologist later noted in his diary, "the town is even more down-and-out than it was possible for me to foresee. The Place des Palmistes is a wasteland . . . Vultures roam the streets."

Smack in the center of Cayenne, in what had once been a gracious Creole home, one could visit the Musée Franconie, inaugurated by the resident French governor in 1901. If the Smithsonian Institution is its own nation's "attic," the Franconie may be considered Equatoria's. A

European journalist captured the flavor in this reminiscence of what he found:

A giant black caiman, varnished. A sloth with open mouth, hanging from a branch by its long nails, belly up. In a fishbowl case, the kepi and epaulets of Governor General Félix Éboué.

A bush filled with hummingbirds. Several romantic pictures: *Victor Schoelcher, Liberator of the Slaves, on His Deathbed,* by E. Decostier, gift of M. Léon Soret, Magistrate; *Rouget de Lisle Singing the Marseillaise* by L. Pils, etching by Rajou; *Washington Crossing the Delaware among the Ice Floes* (winter 1776) by Leutze. A woolly opossum with a prehensile tail.

A series of large glass candy jars where a yellowish fluid holds in suspension fat black spiders like hairy crabs and dozens of snakes of every dimension, spotted, striped, hatched, and marbled. A relief model of the Kaw mountain range with its bauxite deposits. A Boni Grand Man's wooden throne incised with the chief's insignia. The rosary that once belonged to the Reverend Mother Javouhey. A vertebra from a whale beached at Mana about 1876.

The escape boat of a convict imprisoned at the Iles du Salut (gift of M. E. Laudernet). A series of naive paintings by the convict Lagrange, representing scenes in the life of the prison camp. A miniature guillotine for cigars in local wood, an exact copy of the one in the prison camp. The blade and stocks of the guillotine used to execute the bandit D'Chimbo in Cayenne in January 1862, bracketing, from above and below, a

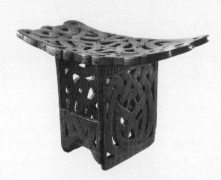

drawing of the famous bandit "executed" in pencil by M.-H.
de Saint-Quentin—a replacement, according to some authorities, for D'Chimbo's actual head, displayed in a jar of formaldehyde.

Although by the end of World War II the gates of the penal colony had finally been closed, its physical traces were still everywhere in mid-1960s Cayenne—the crumbling brick buildings that had once been part of the penal administration, the docks where prisoners had debarked, and the fortress-walled prison buildings now overrun with tropical vines. The couple of hundred *vieux blancs*—leftover French convicts—slept where they could, often under the royal palms in the square, clutching bottles of Algerian red. The mental traces also lingered. Every resident, from schoolkids to the elderly, carried the burden that Cayenne, with its offshore appendage Devil's Island, was synonymous throughout the civilized world with degradation, brutality, and punishment.

During the heyday of the colony, while sailing south from Martinique "on a long, narrow, graceful steel steamer, with two masts and an orange-yellow chimney," Lafcadio Hearn had caught the essence of the enduring myth:

> It is the morning of the third day since we left Barbadoes, and for the first time since entering tropic waters all things seem changed. The atmosphere is heavy with strange mists; and the light of an orange-colored sun, immensely magnified by vapors, illuminates a greenish-yellow sea,—foul and opaque, as if stagnant . . .
>
> A fellow-traveler tells me, as we lean over the rail, that

this same viscous, glaucous sea washes the great penal colony of Cayenne—which he visited. When a convict dies there, the corpse, sewn up in a sack, is borne to the water, and a great bell tolled. Then the still surface is suddenly broken by fins innumerable,—black fins of sharks rushing to the hideous funeral: they know the Bell!

It was on one of those blindingly bright Cayenne mornings, in June of 1964, that Jacques-Émile Lafontaine picked his way down the gangplank of the *Jeanne d'Arc*, which plied the waters between Marseille, Fort-de-France, and the colonial capital of Equatoria. On the quai, Yves and Claude, who had arrived on the previous month's voyage, waved their hats from the middle of the crowd and shoved their way toward their friend.

"And the journey?"

"Fatiguing—quite fatiguing. But I must say the meals were passable. Some excellent Bordeaux."

Once he settled in, Lafontaine chose a different path from his businessman-friends. As a recently certified lycée teacher, he was assured a steady income. In fact he now benefited from the forty percent salary supplement received by all civil servants in France's Overseas Departments. But he soon found that expounding on Rousseau or Racine to an indifferent classroom of Creole-speaking children was less than fulfilling. Not long after his arrival in Cayenne, he decided to make a pilgrimage, via Belém and a tramp steamer up the Amazon, to the legendary opera house of Manaus. It was a place he had dreamed of as an adolescent, whiling away summer afternoons listen-

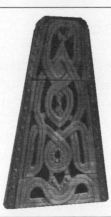

ing to Puccini on his mother's Victrola in their comfortable home
overlooking the Bay of Algiers.

Belém was a revelation, his first truly tropical metropolis—half a
million exotic people crowded near the mouth of the world's greatest
river. He spent hours sitting on a wall by the docks, shaded by the
iron scaffolds of the Ver o Peso Market, drinking mildly hallucinogenic
soup from calabashes proffered by Indian women, and staring, trans-
fixed, at the muscular stevedores unloading crates of merchandise from
riverboats of every age and description. And then the leisurely ten-day
voyage up the Amazon, with innumerable stops at trading docks to
load firewood for the vessel's noisy boilers, passengers dozing in ham-
mocks slung on deck, silent Indian canoes pulling alongside to sell
green parrots, and the dramatic arrival around a bend in the river at
the magical city of Manaus, then in the early stages of rebirth.

As a youth, he'd been much taken by stories of how, during the
late-nineteenth-century rubber boom, the wealthy families of the Ama-
zonian capital had sent their dress shirts all the way to Lisbon to be
laundered and how, in 1912, the bubble had suddenly burst and the
city been left to slide into decrepitude. Now it would soon have a
million inhabitants and serve once again as the hub of one of the
world's last "undeveloped" regions. He could feel the pulse. He could
smell the sense of promise in the sultry air.

That evening, stepping off the steamer onto the crowded dock, he
hailed a boy to carry his bag and asked to be taken directly to the
Opera. There it was, at the end of the cobblestone street, the Teatro
Amazonas! Though its shell was in moldy disrepair, its four-tiered
balconies were crumbling, and paint peeled in great whitish sheets off
the famous diamond-studded ceiling where nymphs, cupids, and satyrs

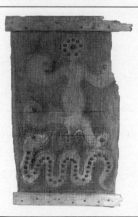

still cavorted on patches of fading frescoes, he found himself trembling, looking up at the vast interior space, now crisscrossed by fast-flying bats, where Jenny Lind had sung and the Ballets Russes had danced. Out on the street again, he found a boarding house and took a tiny room above a saloon. After a couple of Antarctica beers, a heavily peppered plate of rice and beans, and the better part of a bottle of Pitú *cachaça,* he fell exhausted into his hammock.

It was the next morning, at the edge of the sprawling Municipal Market with its cages of jaguarundis and parrots, that Lafontaine had his epiphany: a group of Mundurucú apparently just out of the forest—short annatto-decorated women with pendulous breasts, fierce men in scarlet loincloths, faces tattooed with what looked like giant outstretched wings. He wondered whether, under the loincloths they had adopted for city wear, the men had on the traditional three-cornered penis covers suspended from a cotton cord that he'd read about in a book on Amazonian Indians. The Mundurucús had surrounded themselves with basket after basket overflowing with brilliant, multi-hued featherwork: diadems and aprons, capes, girdles, and necklaces. The softness of the feathers gave him goosebumps. He bought what he could and hurried back to his room, where he finished off his bottle of *cachaça* and tried on the feathers, balancing on a stool before a rust-flecked mirror.

Over the course of several Christmas and Easter vacations in Belém, even then only a three-hour flight away, Lafontaine became an honorary member of the local circle of aficionados of jungle animals and exotic artifacts. Most evenings they gathered for drinks, conversation, and other pleasures at the ironically named Catedral, near the docks. Some of the more respectable members of this group were

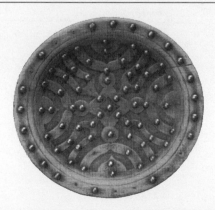

patrons of the Museu Goeldi, an international center for the scientific study of Amazonian flora, fauna, and Indians. In its private park in the center of the city one could, for only a few hundred cruzeiros, sit on a bench shaded by flowering jacarandas and an enormous silk-cotton tree, and watch agoutis and peccaries wander by. But there were also the rough-and-ready traders in birds and animals, who traveled upriver, bought directly from Indians, and sold to anyone in town who had the connections and experience to get this living booty safely over the border. Monkeys, sloths, boa constrictors, jaguars, parrots—there was something for every taste, and the private market in Europe seemed insatiable.

Lafontaine's first animals were exported by boat—the mouth of the Amazon was ill-patrolled and exchange rates made francs attractive to both fishermen and the occasional customs inspector. By this time he had become friendly with officials in Cayenne who would stamp in his crates with barely a wink. Behind his modest bungalow in Montabo on the outskirts of Cayenne, Lafontaine, who had always liked to tinker, began building wooden cages. Within a couple of years, as a sideline, he opened a modest, semi-private zoo.

In the mid-sixties Cayenne was still best known to the outside world as "The Land of Eternal Punishment," or sometimes more simply as "Green Hell." But it was, by official French decree, about to be transformed into "The Land of Space Exploration." For the glory of France, President De Gaulle in faraway Paris had decided to create "a French Cape Canaveral," and the state would soon be pouring hundreds of millions of francs into a new satellite-launching station at Kourou, an hour to the west of Cayenne. This sleepy former colony—now barely 35,000 people, even when you counted in the

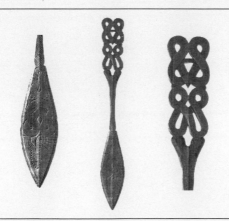

thousands of Indians and descendants of escaped African slaves who lived off in the forest beyond the state's administrative control—had been targeted to become a thriving, thoroughly modernized offshoot of France, what De Gaulle liked to envision as the nation's "show-window in the Americas."

The construction of the European Space Center in fact brought great numbers of visitors—engineers, rocket scientists, computer technicians, and their families—for short stints in Cayenne. Among those who found their way to Lafontaine's suburban zoo were many eager to take home a souvenir. He soon determined that the only convenient way to export endangered species was on the military planes, not subject to customs inspection, that flew more and more frequently to and from the metropole, carrying the gendarmes and legionnaires needed for the beefed-up security of the Space Center. Europeans—*métropolitains,* as they're known in Equatoria—socialized with their own kind, and Lafontaine was soon on sufficiently good terms with the military dispatchers at Rochambeau Airport to have pretty much anything he wanted loaded into the bellies of the dull-green army cargoes.

At the same time, through the Amazonian featherwork he was bringing back in increasing quantities from his Brazilian jaunts, he was gaining a reputation as Cayenne's only serious collector of primitive art. The network of Brazilian collectors stretched from the Peruvian port of Iquitos, far up the Amazon, all the way down to Belém, and then overland to the wealthy metropolises of the south—Rio and São Paulo. But nearly everything moved through Belém, and Lafontaine's friends often served as middlemen, trading with one another, passing pieces along, selling to the occasional tourist or even museum curator from Europe or America.

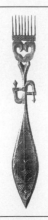

What these men shared was a passion for feathers, for money, and for risk. In addition to collecting, some got involved in simple repairs, and then more extensive restoration, filling in the missing parts of the older examples of Xingú feathered crowns or Wayana initiation breast-plates that came into their hands. Lafontaine fit comfortably into this milieu, with its disdain for officialdom, its sophisticated aestheticism, its diffuse concupiscence, and its greed. When the opportunity pre-sented itself, he purchased a *pied-à-terre* in Belém, paying in cash.

Because of recent legislation and growing international pressures on Brazil, rare feathers had become one of the most difficult of all materials to move across the border. Through his drinking buddies, Lafontaine befriended a pair of army colonels as well as several high officials in the FUNAI—the government service charged with protect-ing the welfare of Indians—and on more than one occasion they got him out of tight spots, fudging a document here, putting in a phone call there. He figured out how to dismantle the more elaborate feath-ered objects without damaging them, to secrete the plumes under his clothing, and to reassemble the whole back in the privacy of his home outside Cayenne.

Over the years—mainly in Brazil, but on trips to visit his mother in Paris as well—Lafontaine scavenged in second-hand shops for books on Amazonian featherwork. He particularly treasured, for its detailed pen-and-ink sketches, an unbound, heavily illustrated monograph by a Brazilian named Darcy Ribeiro, which he had picked up in Belém. He'd also bought a couple of more common volumes on the art of woodcarving, as practiced by the blacks who lived in the forests of Equatoria, especially those known as Bonis and Saramakas.

Of an evening he liked to put on Tosca and turn up his hi-fi as he

lingered over a book about these descendants of rebel slaves, written by a French geographer and filled with detailed explanations of the sexual symbolism of carvings—and with stunning photos of Boni men. And though he could barely read English, he'd bought, on the rue de Seine, a book called *Afro-American Arts of the Suriname Rain Forest*, which he enjoyed for its pictures of Saramaka woodcarvings.

By the late 1970s Lafontaine was devoting less and less effort to his teaching and his zoo, and using most of his spare moments to perfect his collection of feathers. He also bought a red MG convertible, and began to play something of the dandy, riding around town accompanied by a pet ocelot in the adjoining bucket seat.

"Whitefolks sure are funny," Saramakas like to say. Those who had come over to Equatoria from neighboring Suriname to work as woodcarvers or day laborers sometimes saw Lafontaine driving around in his sportscar with a jungle animal they considered sacred, as well as dangerous, and they figured he must have some mighty strong powers—or else be crazy.

He began frequenting Saramaka camps by the side of the road, leaving the leashed cat in the car. The ambience he found exotic, and both the art and the carvers attracted him. Though he couldn't understand their language and knew little *patois*—the vernacular of Equatoria, normally used by these carvers to communicate with their customers—Lafontaine spent enough time hanging around the ateliers to gain a good sense of the woodcarving business. Through repeated visits he developed a few deeper relationships—one with a talented artist named Konfa, who lived at the edge of the forest, south of the city.

Unlike most Saramaka carvers, Konfa spoke some French. Back home, along the Suriname River, he was well known as an artist—first

for his creative grace in *sêkêti* dancing, then for his masterpieces in wood. He was also a hunter of renown, and his ability to attract and support several young and beautiful women at a time had gained him respect as a "many-wife-man." He'd been in Equatoria for a few years by the time he met Lafontaine. His athlete's body had begun to go soft and he now wore gold-rimmed spectacles when he worked. His temporary French work permit listed him as forty-four, roughly the same age as Lafontaine.

Konfa encouraged Lafontaine's interest, having his wife bring out a folding chair for him to sit on while he watched the carving take shape and, when it was mealtime, offering him a plate of rice topped with fish or meat. Partly by leafing through the geographer's book with Konfa, Lafontaine began to develop particular tastes in design, and soon he was commissioning objects, mainly drums and paddles. Some of these he gave to Yves or Claude or Patrick as presents. Others he began to sell, through his feather connections, in Europe. He discouraged Konfa from carving in a tourist style, since he found that paddles embellished with more traditional designs brought a better price. Konfa didn't always feel comfortable when Lafontaine watched him work, but he put up with the visits as long as the Frenchman kept buying.

Perhaps we didn't really belong at the funeral. After all, our relationship with Lafontaine had not exactly been an open one—on either side. As long as he was still alive, we'd lived with an uncertain fear for our safety, never knowing whether he was aware of what we were uncovering about his life, never knowing precisely what he might do

if he found us out. Now at last we felt freed from that gnawing anxiety. And also freed to tell the story, as we'd been able to piece it together.

Our own, indirect introduction to Lafontaine was through the director of a museum—but not the old-fashioned Musée Franconie. Far from it. The Musée d'Equatoria, scheduled to open for the 1992 Quincentenary, was being planned as a distinctly post-colonial, state-of-the-art contribution to the cultural development of late-twentieth-century Equatoria, a celebration of its diverse peoples and cultures. At the ceremonies announcing the project in 1989, a local politician struck the theme: "In the flood of recent cultural projects, we have one central objective: the quest for our identity, the search for our patrimony, which is also the new course we would like to set in order to discover and bring to life the New Man of Equatoria." The first "Detailed Technical Plan" for the museum expressed the reigning sense of urgency:

> At present, Equatoria is a land of profound economic, social, and cultural change. For this reason, traditional ways of life are faced with outright oblivion and disappearance. The transformation is taking place before our very eyes. In Equatoria, the situation is URGENT. The cultural goal of the museum demands immediate attention. The traditional cultures are in peril. Lifestyles, ways of speaking, languages, everyday technology, musical instruments, etc., etc., are on the road to oblivion. To meet the challenge, it is therefore necessary to *go fast* and *do everything at once.*

The newly appointed director, a Creole with a recent doctorate from a university in France, quickly assembled an international advi-

sory board and invited activists and other representatives of various ethnic groups from the hinterlands to join her in the preliminary planning. At the same time, state funds were appropriated for temporary offices, administrative staff, photography, data processing, and conservation, as well as for museological collecting.

Even though we weren't French, we had been asked—as anthropological specialists on the Saramaka and other Maroon populations of Equatoria's interior—to become members of the Comité Scientifique. In order to ensure fair representation of the Maroons, we agreed, though with serious reservations. We realized that the museum was enmeshed in a general modernization project toward which we felt somewhat alien: defining a new pan-Equatorial identity (within the constraints of the overarching French state), effecting the rapid "Frenchification" of the more "primitive" segments of the population (Amerindians and Maroons), and dealing with the more dispossessed residents (including recent immigrants such as Haitians, Brazilians, Hmong, and Surinamers) through either full assimilation or expulsion. We also understood that the creation of the new museum was not going to be easy. Politics and economics aside, the future museum owned no collections.

By the summer of 1989, however, the dynamic director already had French and Swiss anthropologists fanning out through the interior of Equatoria to collect from various Amerindian groups, and had made plans for additional specialists—including us—to conduct the Maroon collecting during 1990. She was also scanning auction catalogues from Europe and America and negotiating long-term loans with better-established museums on three continents.

In early 1990, well before we arrived for our collecting trip, the director was approached, through a phone call, by a Monsieur Lafontaine who said he had some pieces that might be of interest. She smiled when she heard his name, recalling how she and her highschool girlfriends used to imagine the secret life of this metropolitan teacher, tooling around in his convertible like a diminutive James Bond with a goatee. She'd heard he had a little zoo and might be involved in the illegal traffic of endangered species. And that he'd stopped working at the lycée.

Now, through her connections with people who worked at Air France, at the State Tax Office, and at the Prefecture, she was able to determine more—that he had apartments in Belém and Cannes, that he traveled often, and that he sold a good deal of ethnographic art by proxy, through the back rooms of the pricey souvenir and jewelry shops run by his metropolitan friends. The several people she discreetly consulted left no doubt that he was the premier private collector of Amerindian and Maroon art in Equatoria. She called him back and accepted his invitation to view the collection the following Tuesday.

Lafontaine opened the door, shook her hand, and led her through a dark hall hung with feathered crowns and collars, down a tight spiral staircase, and into his fourth-floor duplex. He was older and smaller than she'd remembered. She took the leather chair he offered and let her eyes adjust to the interior gloom.

"I have a bottle on ice," he announced, and went off to the kitchen. Setting two flutes and the Laurent-Perrier on the coffee table, he popped the cork and poured. "Here's to the success of the museum!" he said with a smile. The director, who rarely drank alcohol, touched the glass to her lips.

"As I mentioned on the phone, I have recently had the good fortune to come into the possession of some extraordinarily rare pieces, part of a Creole orchestra from the epoch of slavery. They could be, in my humble opinion, the very centerpiece of your museum—especially if, as I have every reason to hope, I can complement them soon with others from the same source. Let me show you the trumpet." He held it up in his two hands, as if it were a votive offering—a dark wooden horn, lightly streaked in white, with a distinctive raised lip (111).*

The director had vowed to be composed and indifferent, no matter what Lafontaine might show her. She turned the horn in her hands, squinted at it, and set it back on the table without a word. "I also have its mate," he said, reaching into an antique Iberian trunk and pulling out a similar instrument (69). This one had three finger-keys, in ivory or bone, protruding from the wood, as well as a braided fiber tie, decorated with a single cowrie shell. She remained impassive, remarking only that it looked a bit older than the first. "I am no scholar," he said, "but I have noticed pictures of such trumpets in the book of Captain Stedman." Indeed, she too remembered seeing those engravings of eighteenth-century rebel slaves using horns to signal one another in the forest.

"And there are Negro banjos," he went on. "Would you like to come over here where I've laid them out?" On the floor, on a pastel blue bedsheet, he had arranged three instruments, in various states of disrepair. All had bowl-shaped soundboxes, two covered in animal

* See page 111 for the relevant image. Throughout this book, numbers in parentheses refer to illustrations in the same manner.

skin and one in wood. Each had four strings. There were rickety bridges and wooden tailpieces on two of them, and all had ambiguous little points, almost as if they might have been played vertically, like a cello. The one covered in wood had an elaborate S-hole to one side of the strings and wooden pegs attaching that surface to the sound-box. Each of the others had its S-hole carved into the side of the soundbox itself. On two of the banjos the tuning pegs were executed in extravagant openwork, and on one of these, as well as on the banjo with the simplest pegs, they were encircled by rings of bone (55). The two banjos covered in hide had carrying straps—one woven, one crocheted, and both a bit ratty from wear. The director imagined them being carried over the shoulder by a slave going to serenade his lover.

"They made violoncellos, too" Lafontaine said, indicating the next display, further along the parquet floor. He bent down and handed her one of two nearly identical pieces (89).

"Remarkably fine work," she thought to herself. Perhaps they were cellos, but more likely violas-da-gamba. She would have to research that carefully for the labels.

They were in considerably better condition than the banjos. Each was composed of what looked like a turtle carapace soundbox molded into the wooden portion of the finely carved instrument. Each had large double S-holes under the bridge, end pins that had been decoratively spiraled, four elaborate openwork tuning pegs encircled with bone rings, and, on the neck, two bone finger-keys. And each was accompanied by a gracefully curved horsehair bow inlaid with bone discs.

She'd heard of slave fiddlers but had never imagined such refined European instruments on a plantation. The use of local turtle shells would be sure to draw enthusiastic comment in the press.

"Extraordinary," she let herself exclaim.

Lafontaine gave a satisfied nod. "And now for my real surprise." He led her into an alcove and flicked on the light.

Before her stood a large harp, unlike any she had ever seen (113). On a wooden stand held together with pegs rested a gigantic armadillo shell. The wooden portion of the instrument curved upward, ending in a series of pegs and spirals. A checkerboard of bone squares embellished the top of the soundbox, whose carved spiral protrusion seemed to be simulating the armadillo's tail. A round stool, which she thought looked Boni or Saramaka, had similar checkerboard decoration. "It's for the harpist to sit on," Lafontaine offered.

They settled back into their chairs, she indicating that she didn't need anything more to drink. "Well, Madame, now you've seen for yourself. What do you think?"

"Very interesting. Of course, I'd need to know something about their provenance."

"It's a fascinating story," he replied with visible eagerness. "For some years I've maintained contact with an elderly gentleman in Paramaribo who comes from an old planter family. He's no longer in the best of health, and the civil war in Suriname has caused him financial distress. From time to time, during the past few years, he has sent me messages that he's willing to sell a piece or two from his collection."

"Where did he acquire them?"

"From his father. The father was the real expert. He had a notebook which the son showed me once, where the history of every piece was inscribed—the name of the slave who made it, what year, and for what occasion.

"You see, on this family's plantation, each time there was a birth the master would commission his slaves to manufacture an instrument. Over the course of a century, they made I think thirty-two—that's what he told me—but I haven't seen them all. He keeps them in a storeroom all jumbled together, a veritable *marmelade* of objects, and it is only with the greatest patience that I've been able to rescue the pieces you have just viewed. But I have hopes of obtaining more soon—and you, Madame, will be the first to have the opportunity . . ."

"When did you say they would have been made?"

"At the time of Captain Stedman, in the eighteenth century, though perhaps a few in the nineteenth. Whenever there was a fête or ball or marriage on a nearby plantation, the proprietor would rent out his slave musicians, with their instruments. Let me show you a similar one that Stedman collected."

He went over to the bookshelf, pulled off *Afro-American Arts of the Suriname Rain Forest,* and opened to the image of a calabash-shell banjo, very much like one on the floor, that had been collected from a slave in the 1770s (99). "This one's the oldest known banjo from the Americas," he translated. "Except perhaps for mine," he added, looking pleased. "Who knows?"

"This book," he declared, tapping it with an index finger, "is my veritable Bible. It's always the first source I consult when I'm offered a piece of Negro art."

The director decided to take her leave. "I need some time to consider. Might we arrange for the pieces to be deposited for a few weeks in our storeroom, for closer examination?"

"I'll bring them over myself in a few days, after I've had a chance to clean them up a little," he said.

As he spoke, Lafontaine tried to mask his excitement. He knew this could be a major breakthrough for him as a dealer. The museum was operating with a generous budget, and would surely have international visibility. Who knew where such public recognition might lead? In any case, experts would now undoubtedly be brought in— perhaps the authors of his "Bible." And he felt confident, if a wee bit nervous, that his pieces would pass muster. Though it was not really any great concern of his, he took secret pleasure in the idea that the art history of this part of the world might well need to be rewritten to include these remarkable finds from Suriname.

Back in her office, the director looked again at the image of Stedman's banjo in the book. That piece was in the Royal Museum at Leiden. What if she could get one almost like it? And one of Lafontaine's wooden trumpets had looked very similar to the one illustrated in Stedman's engraving of "Musical Instruments of the African Negroes." In fact, she could make out no difference at all.

From the beginning, she'd feared that the Creole section of the museum would be the hardest to complete. The primitive cultures of Indians and Maroons lent themselves naturally to museum vitrines, but that of her own slave and freedman ancestors was less well known and had left fewer material traces. These magnificent instruments—the turtle-carapace viols, the armadillo-shell harp—with their brilliant adaptations of European forms to the tropical environment, could provide a symbolic focus for the whole museum, a metaphor of the process of creolization. The first thing was to raise some money. She was sure that Lafontaine wasn't about to part with these rarities for peanuts.

Indeed, the morning he arrived with the instruments, he handed
her an envelope with a one-line, handwritten note: "250,000 for the lot."

She had nothing in her normal operating budget for a purchase of
this magnitude. But she did know what she had to do, and asked her
secretary to get Monsieur Jean-Rose on the line. "Luc," she said,
"How've you been? Look, I have some pieces I need photographed
soon, and nicely. Can you come this afternoon?"

Getting good photographic work done was always a problem.
Metropolitans had taken over much of the local market, with big
studios and fancy new equipment. In principle, she didn't want to be
part of that scene, and continued to support the more artisanal Creole
tradition of photowork she'd known all her life. The problem was that
the pictures were sometimes fuzzy or poorly framed, and there was a
tendency for negatives to get misplaced. Jean-Rose shot the instru-
ments with his aging Rolleiflex, doing his best to catch their strange-
shaped volumes. She asked him for twenty sets of color prints, as soon
as possible.

By letters to France and a series of meetings with local politicos,
the director began putting together a package. "The LAFONTAINE
Collection, so-called after its present owner," she wrote in her formal
presentation,

> includes eight antique musical instruments (late eighteenth–
> early nineteenth centuries), in a perfect state of conservation,
> which belonged to a Surinamese collector from a Dutch planter
> family. They are among the very few of this kind in world
> collections (the Museum of Washington, for example). In
> order to avoid the serious consequences should this collection

be sold to foreign parties, a step that is already being contemplated by its owner, it is crucial to act without delay and to complete this rescue operation designed to preserve our national patrimony.

To the sponsors in Cayenne and Paris, it mattered little that she had displaced Stedman's collection from Holland to "the Museum of Washington" (apparently an attempt to invoke the Smithsonian). On the strength of her statement, bolstered by active lobbying and Monsieur Jean-Rose's photos, the local state legislature, made up largely of Creoles, voted 100,000 francs to preserve this precious part of Equatoria's heritage for future generations. And the Directorate of French Museums, in Paris, agreed in principle to grant her 200,000 francs, with the standard condition that 50,000 be used for an expert appraisal.

She was surprised at how easy it had been. Although Lafontaine phoned at least once a month, hinting that he was in contact with other interested parties, she enjoyed letting him sweat a bit. She knew she would be ready when the time came.

Which is where we entered the story. The director, as always playing her cards close to her chest, decided to send us a fax at the Stanford Humanities Center, where we were spending the year as visitors. "I append to this fax several photos representing a set of musical instruments which have been proposed for sale, and ask that you be so kind as to let me know your sentiments on the subject. *A priori,* the instruments appear to be authentic antiquities."

We held the glossy paper in front of a window to try to make out the details. Two of the instruments—a sidehorn and a banjo—looked like dead ringers for Stedman pieces. What a coup they would be for the new museum! The horn Stedman sketched in the 1770s had long been thought lost, and his banjo had been tucked away in a storeroom of the Leiden museum, mislabeled and unnoticed for over a century, until we rediscovered it in the 1970s. We were quite certain that no other instruments of this vintage existed anywhere in world collections.

And now suddenly here were eight. Besides the two Stedman look-alikes, there was a three-keyed variation on the Stedman horn, as well as two interesting variants on the Stedman banjo. We'd never seen any-thing like the little cellos, nor could we identify from the pictures their strange soundboxes, but they were beautifully crafted. And the gigantic harp, while totally beyond our experience, was extraordinarily graceful.

We tried to remember the exact instruments depicted in a litho-graph of Suriname slaves dancing in the 1820s that we'd seen in a colleague's home in Amsterdam. There had been a mouth-harp and a large mandolin as well as a fife and drums, but on artistic grounds they didn't even come close to the pieces in the fax.

We knew the director was asking for an immediate verdict, based on that hit of instant recognition that real connoisseurs are supposed to experience. But we felt distinctly uncomfortable being cast as par-ticipants in the appraisal game, Sally in particular. She'd recently published an essay called "The Mystique of Connoisseurship" on claims by twentieth-century connoisseurs—from Joseph Alsop to Nel-son Rockefeller—that they made their judgments on the basis of "in-stinct," that they were blessed with a kind of inborn "eye" for quality, a rare gift that some people had and most did not. In it she had argued

for the relativity of artistic taste—through time and across cultures—and hinted at the misplaced conceit of those who imagined that what they "felt" carried universal and absolute validity. And she had picked away at the whole system based on the assumption of a global authority by this elitist establishment—a system encompassing the art market, museums, and the discipline of art history.

Since the publication of that essay, and the testy responses it was beginning to provoke from the art establishment, we had been moving even further, wondering to what extent the whole system might not be seen as a giant con game. After all, Lord Kenneth Clark—England's premier connoisseur—had written shortly before his death, "My whole life might be described as one long, harmless confidence trick." And Thomas Hoving of the Metropolitan Museum in New York had been bragging in best-selling print for some years along the same lines. Just as the gourmet is closer to the glutton than might at first sight appear, so—we'd been thinking—the connoisseur and the con man might be seen, from a certain perspective, as variations on a theme.

We brought the fax down to lunch, to share the story with colleagues at the Center, and told them of our dilemma.

"If it's anything like Africa," said an English professor who collected tribal art, "much of what's on the market today is fake and buyers have to be very, very savvy. I shan't bore you with anecdotes from my own trips to Abidjan, but it's common knowledge that a trader in Ivory Coast will take a newly made mask and smoke it for a few weeks in a cooking fire, let it weather for a while in a termite hill, and rub on soot—it's the process more technically known as 'distressing.' Then he'll tell the buyer that the mask has 'been danced,' which of course gives it much greater market value."

"But the difference in the Guianas is that there's really no market," countered Rich. "It's true that the occasional Maroon carving is sold by a dealer in Europe or the States, but they're not high-priced items. I don't see what motivation there'd be to fake that kind of art since there's still plenty of the real thing sitting around in the villages. Demand doesn't exceed supply. In fact, I don't think there's such a thing as a 'fake' piece of Maroon art in the world. At least we've never heard of one. It's totally different from Africa. And there would be even less of a market for Creole pieces, which are what these instruments are supposed to be."

Sally picked up one of the photos and pointed to the tuning pegs. "Besides, it's not just a question of authentic or fake," she said. "There's that whole gray zone that combines artistry, bricolage, restoring, and repairing. That's where a lot of what's interesting about appraisals happens." She noted that the overall resemblance of the banjo to the eighteenth-century slave instrument collected by Stedman seemed to stop at the tuning pegs, which didn't look, at least from the faxed photos, as if they were slave- or Creole-made at all. They looked more like a kind of Saramaka carving that was developed around the turn of the present century. Still, she admitted, that could be part of the normal life history of such an object: if the original, eighteenth-century, slave-made pegs had broken, replacements could easily have been commissioned from a Saramaka carver sometime during this century.

Before we could carry the discussion further, a colleague in history asked somewhat aggressively how anthropologists felt about accepting money in return for "expertise." Rich reiterated his discomfort about the whole system of high-stakes games, citing consequences for the players' income tax, personal careers, public funds, and even the

writing of art history. It wasn't a part of the art world that we'd ever had any inclination to participate in. And besides, he said defensively, money isn't involved here: we aren't being paid.

A literature professor at the table made the point that while most university scientists earn a good portion of their income from outside consulting, humanists rarely can—except for art historians. Sally added that in the United States art appraisals tend to be done by art historians from the academy, while in Europe they're more often done by licensed full-time professionals. And so the discussion went, skipping from one semi-relevant observation to another, but ultimately doing nothing to resolve our uncertainties. We'd met the director of the museum only once and very briefly. We knew nothing about the dealer. We were aware that a lot could be at stake for each of them. Our reply was composed with care:

> The musical instruments seem quite interesting. Although we cannot come to any firm conclusions on the basis of photo-copied images, we would guess that there is a real possibility that they are "authentic antiquities." The only instruments of this type in museums come from the collection made in the 1770s by John Gabriel Stedman on the slave plantations of Suriname. Your photocopies suggest that these instruments, were they to prove genuine, would be of considerable ethno-logical interest not only for Equatoria but for the history of Afro-America more generally.

In the same fax we informed her that we had finally made the plane reservations that would bring us to Equatoria for a summer's collecting expedition among the Maroons.

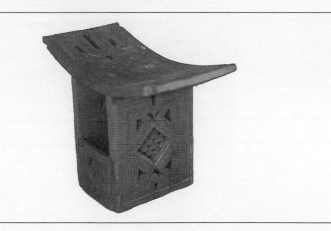

We arrived in Cayenne in July. Although the director in no way revealed her thoughts to us, she had, for all intents and purposes, already made up her mind. The funds had now been placed at her disposition by both Paris and the local government, and the arguments for going ahead seemed overwhelming. Within the small world of regional museums, this would count as a major acquisition, her first "world-class" art objects. That they were Creole masterpieces rather than rain forest ethnographica lent them even greater cachet.

With Lafontaine on vacation in France until late August, and with us in her office, the director decided to reassure herself one more time that she was not doing something that could turn out to be an embarrassing mistake. She invited us, along with a visiting anthropological consultant from France, to have a look at four of the instruments, which were arrayed on her bookcase. We briefly handled the horn and banjo that had reminded us so strongly of the Stedman pieces, thinking they were almost too good to be true, but we really didn't know what to make of the set as a whole. The director told us little to help make sense of their historical context, and in any case they were almost surely slave or Creole artifacts, a bit outside our primary area of expertise.

By summer's end, when we returned to Cayenne from the interior with our trunks full of 50,000 francs worth of ethnographica for the museum, it was a done deal. Monsieur Lafontaine's bank account had been augmented by a transfer of 250,000 francs.

The director began her busiest period ever. She now had the sense of almost unlimited funding for her museum. Support was building in the

local community and state legislature, and she was processing the successful collecting efforts of the summer, training a data-processor to enter documentation on those objects in her new computer system, and working out administrative details in consultation with museum experts in the metropole. She was also devoting considerable time to building the all-important Creole component of her collections, by attending social functions and visiting potential donors. At auctions of colonial furniture she did her best, though she was frequently outbid by agents for posh Martiniquan hotels seeking period pieces. She was in almost daily contact with her French anthropological advisor about the architectural competition for the museum, and a winning design was finally chosen in November. At the same time, she was overseeing the moving of her collections in storage to more ample quarters at the other end of town. And she had made the difficult decision to dismiss her lackadaisical curatorial assistant, causing a minor scandal in the tight little society to which they both belonged. As part of this flurry of activity, the director found herself crossing paths increasingly with Lafontaine, either in person or, more often, at a distance.

One of her duties as director of the museum was to oversee the protection of Equatoria's cultural patrimony. In principle, this meant she had the right to block the export of any object so designated. In practice, she was spending much more time than she wanted trying to follow up tips and force customs inspectors to obey the letter of the law, often in the hours or minutes before the shipment in question was to leave Equatoria's soil.

Through her connections to people in the civil service, she had been able on several occasions to determine Lafontaine's plans, and had succeeded in preventing him from clandestinely exporting to Ger-

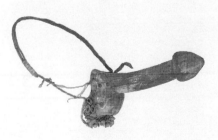

many a half-century-old Wayana Indian headdress and, later, a large Creole cassava mill.

Various bits of intelligence that came to her ears convinced her that he had officials in high places who were helping him bypass export restrictions. Indeed, some discreet sleuthing on her part had allowed her to determine that each of her requests for cooperation from the prefect to stop the export of a particular object had been leaked to Lafontaine before he could be caught in the act. From reports about what he was managing to get onto military planes and what he was receiving on in-coming flights, she realized that he was shuttling much of his inventory around between his residences in Cannes and Cayenne and Belém.

Although Lafontaine was aware of her interference, and furious about it, he eventually managed to sell the headdress to a wealthy European visitor, who simply carried it out in his suitcase on Air France. And when the director herself approached him, with appropriate delicacy, about the possibility of selling the cassava mill to the museum, he agreed to let her have it moved to her storerooms for consideration.

She was beginning to see this little man as a case waiting to be broken—but someone who still might be of use. That was why, when the opportunity presented itself, she found an excuse to take a snapshot of him holding a plumed headdress, on the general principle that it might come in handy some day.

It was in the same spirit that she had taken possession of another item of potential interest. When Lafontaine visited her office to discuss the cassava mill, he suffered one of those *malaises* that were becoming increasingly frequent, and more and more frightening to him and his friends. After the two flights of stairs, his weak heart left him puffing

and gasping for air, pale and sweating. As the director and her secretary helped him into a chair, the folder he was carrying spilled onto her desk and she was able to scan the contents of several sheets. Acting quickly, she slipped two of them to the secretary to photocopy in the adjoining office, and got them back in place by the time he'd taken his medication and was sufficiently recovered to talk.

He had rescued the cassava mill, he explained, from an old plantation—which he declined to identify—some distance from Cayenne. Several pieces had been missing, as the mill hadn't been used in decades, and their replacement had cost him months of research. But it was now exactly as it had once been, and there were buyers in several countries—museums, too, he hinted—who were ready to snap it up. Whether she bought it or someone else did was all the same to him. But he hoped she would have the courtesy to reach a decision quickly and, if she didn't want it for the patrimony, allow him to export it.

The mill puzzled her. It was two meters high, powered manually by means of large wooden spokes that turned a pair of spiked horizontal rollers, one over the other. On top was a rustic little roof sheltering a miniature saint's altar. The pieces fit together crudely— perhaps a combination of weathering and extensive repairs. She called in various local experts on Creole traditions and technology, and received as many divergent opinions. It looked more Brazilian than Equatorial, she thought. But if it was genuine, it belonged at the very center of her Creole exhibits. She wavered. Whatever the verdict, she wasn't about to let him send it to Berlin.

In May 1991, Lafontaine phoned to say he was prepared to show her a number of new pieces, this time mainly Saramaka, and quite ancient. His health, he reminded her, was deteriorating, and he wished

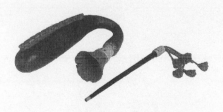

to clear out his inventory. "Indeed," he said, "I am thinking seriously about moving back to France for good."

This didn't surprise her. She knew that his friend Claude was closing his publishing house in preparation for his own move back, and she'd heard from a neighbor that any time now Patrick, another member of the circle, was expected to put his seaside villa on the market. This might be her final opportunity to tap into the collection Lafontaine had been assembling for some twenty-five years.

She asked him if he would entrust the pieces to her over the summer, since he'd mentioned that he was going off on his annual vacation within the month. He agreed to let her have the storeroom assistant drive over in the museum van to collect the twenty-eight items.

A few days later Lafontaine paid the director a visit, both to see that his pieces had been properly received and to tell her a bit about them. He was also eager to know her decision about the cassava mill, as he'd soon be seeing potential clients in Europe. She held him off about the mill but allowed him to talk about the objects that now filled a whole room on the second floor.

"Most of these pieces," he told her, "come from that same gentleman in Paramaribo. Recently one of his sons found himself in difficulty. To be frank, he's in jail in Caracas for murder—and the father needed a large sum of money *pronto*." He rolled the r. "It seems that the old family plantation was in a district inhabited by Saramakas, and over the course of time they collected a stool or a drum here, a paddle or a tray there, until by his father's time they had a whole roomful. The objects were in ill repair and very dirty when I received them but I've succeeded in making them rather presentable, don't you think?"

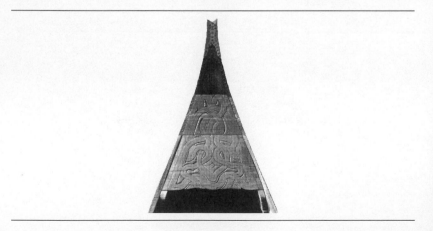

She declined to give him the satisfaction of a reply, but admitted to herself that it was a stunning collection, of a quality unmatched except perhaps in the Musée de l'Homme or in Holland. There were canoe prows, a number of wooden objects encrusted with snakes, some more fantastic musical instruments, and a large, very realistic wooden phallus attached to a waist-tie. "The phallus and its accompanying mask," he said, following her eyes and nodding toward a funeral mask across the room, "were sold to me by a mining engineer named Breton. He told me he'd obtained them from a Saramaka who came over to the village of Papaïchton for a Boni funeral. Breton was prospecting along the Lawa for tantalite—that's a rare black mineral Americans used at the time in their transistors." In fact, she did remember this Monsieur Breton, a Frenchman who'd been married to a Creole woman. He had died ten or twelve years before. Monsieur Lafontaine's stories were beginning to fall into place.

"By the way," she said as they left the storeroom, "I've invited the Prices—the couple who wrote that book on Afro-American art—to come next month and collect for the museum along the Tapanahoni."

"Excellent! I would be honored to meet them, if you could arrange it after my return from vacation. If you ask me, they are the ultimate experts on Bush Negro art."

While Lafontaine knew of us from the art book we'd written, our first direct image of him was the director's color snapshot. We had arrived in Equatoria for the second of our two collecting missions to the interior, and were in her office, being briefed on developments since the previous year. We witnessed the new computer being fed by the

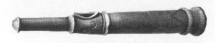

new data processor. We viewed the file drawers that now housed the information sheets from the various collecting expeditions. We pored over the winning architectural plan. And we heard about the set of artifacts being offered for sale to the museum—by the same man, the director explained, who had sold her the eight Creole instruments the year before.

"His name is Lafontaine, and I don't fully trust him," she confided, reaching into the top drawer of her desk. She handed us the photo.

Staring out at us through a pair of tinted aviator glasses was a small masculine figure with a meticulously trimmed beard and moustache. The sleeves of his close-fitting paisley shirt were rolled up to the elbow. Somewhere in his fifties, we guessed. Balanced on one arm was an Amazonian casque with a two-tiered ring of feathers topped by elaborate arched plumes, webs of cotton string, and bead-and-feather tassels.

"I asked him to hold up the headdress so I could get a picture of it," she said with a laugh.

She also showed us the letter she had xeroxed, and offered us a copy. We scanned it together. It certainly confirmed the dubious side of Lafontaine's world that she seemed intent on impressing upon us.

The two handwritten pages, sent by registered mail from Germany, contained advice about hiding the cassava mill and smuggling it out of Equatoria on a military plane. It continued with news that a Suriname-born Dutch client had proffered a check for a thousand dollars to hold the cassava mill (with the rest payable in either dollars or Deutschmarks) and that he also wanted to buy some musical instruments, which he'd seen in Polaroids, if Lafontaine could extend adequate credit. And there was a reference to objects being stored in

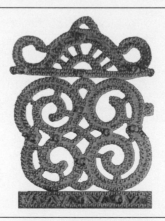

buildings owned by "Claude," as well as several passages of an intimate, personal nature. It concluded with a postscript: "Whatever you do, don't ever mention our little trip to Brazil."

The director asked us whether we would do her two favors. She needed advice about the much larger, more varied, and more expensive collection that Lafontaine was offering for sale. And she hoped we'd help her with some amateur detective work as well. Some of Lafontaine's metropolitan friends, she explained, owned souvenir and art shops. Though she had reason to believe they sold objects to select clients in the privacy of the stores' back rooms, she had never felt welcome—as a Creole—in these milieux. And now that she was director of the museum, it was out of the question for her to visit personally. Might we, she asked, be willing to poke around and report back to her?

As for the new objects offered for sale, she would be leaving for vacation in France in two days but would be pleased if we would simply ask her secretary for the key to the annex where they were on deposit whenever we could find time to examine them.

"Also," she told us, "Monsieur Lafontaine has expressed an interest in meeting the two of you. He claims your *Afro-American Arts* is his Bible and he's hoping to get your reactions to the rest of his collection. You should see his apartment. It's overflowing with artifacts. Even though he's fishing for a professional endorsement, we can certainly make use of the opportunity as well!" She smiled.

"When can we see him?"

"I'm afraid he's on vacation in Europe and won't get back till you've gone upriver. But I can arrange a meeting right after your return to Cayenne next month."

After discussing the logistics of our collecting trip, we got up to

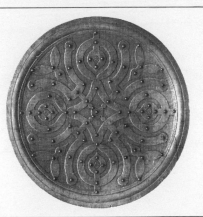

leave and wished her bon voyage. She buzzed her secretary and asked to have her storeroom assistant bring around the museum van so he could drive us to the studio apartment she had rented for our stay. We spent the rest of the day settling in, postponing further work till morning.

The collections had been growing steadily since the first expeditions of 1989, and now occupied a second-floor apartment on a quiet street across town from the museum's administrative offices. A single half-turn of the secretary's key sufficed to open the door to the museum's holdings; the deadbolt hadn't been thrown. Inside, two rooms had been fitted out with deep shelving to store catalogued acquisitions: basketry, wood, feathers, pottery, calabashes, bows and arrows, and musical instruments. A small kitchen served as conservation laboratory. Its single counter held a cracked wooden tray, a Wayana comb with feather decorations, several varieties of glue, some marking pens, a spray vial of Windex, a vise, turpentine, two screwdrivers, a radio, a plastic shaker of Ajax, a notebook, and some pencils. The doorless cupboard contained more artifacts and tools, a comic book, and a box of chocolate-coated granola bars. Opening the door next to the kitchen, we stepped from still heat into circulated cool air. Textiles had been admitted to the shelves of this climate-controlled environment, backdrop cloths and empty film canisters marked this as an occasional photographic studio, and then there was the collection on deposit.

Most of it was spread out on the floor or propped up against the walls. Two canoe paddles (73, 104) and a large food spatula (97) displayed openwork carving in the style commonly found in Eastern

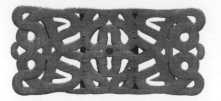

Maroon villages, though the wood was darker than most we'd seen. A stool, worn smooth in the center of its concave round seat, was decorated with a spiral motif, crosshatching, and small bone disc inlays (53). Its base, with checkerboard openwork on two sides, was held together with wooden pegs. We noticed it had an inscribed museum number and realized that this was the stool that went with the harp. We hadn't seen it the year before. Another stool, also with checkerboard panels in its base, had been extended along two of its upper edges by a carved snake whose tongue forked back onto the rectangular seat, plain except for a border motif and an inlay of two giant cowrie shells at the center (112).

A canoe prow with standard Ndjuka-style painting and decorative tacks stood erect on its sawed-off end, tip curving gracefully forward. Next to it was another of similar size, but executed in Saramaka style (4), with a well-worn seat, in bas-relief, that had a 1920s or 1930s look to it. The beautiful tripartite panel toward the prow, carved in openwork, featured the linear incisions and perfectly regular under-over alternation that carvers had come to demand of their interlaced ribbons only in the decades after World War II. The tip of this canoe was covered with metal, apparently copper, rather than the tin we were used to seeing on canoe prows. The variably sized tacks that studded the piece were quite corroded.

There were three trumpets made of what looked like water-buffalo horns, connected to wooden mouthpieces, with carrying straps made of wrapped fibers or strips of hide strung with delicate bone tubes and discs (123). Hanging from one were tassles made of string, bone washers, and vegetable pods. Other musical instruments displayed similar multi-media construction. A partial armadillo carapace had

been extended on one end by a bone mouthpiece and on the other by a wooden sounding bell held in place with pegs, and a mottled conch shell joined what appeared to be an armadillo tail. Both were embellished with dense tassles, though this time ending in dried berries and carved wooden "clappers" rather than vegetable pods.

Several stringed instruments something like mandolins reminded us of those from the previous summer. Each one featured hollow bone "keys" on its fingerboard, elaborately carved openwork tuning pegs (10), a turtle-shell soundbox with decorative incisions, and a decorative peg that fit into a hole at the tip of the neck. There was also a bottle gourd with a bone-and-wood mouthpiece and a ridged panel, apparently for scraping; a black stick with silky gold tassles suggested itself as the scraper (29). All these instruments, like those the museum had bought the year before, appeared to be non-Maroon. Presumably, they too were made by slaves or their Creole descendants, though some parts looked as if they had been repaired or replaced by Saramaka carvers.

Across the room from the canoe prows, another carved object stood erect on its base, curving majestically upward. Though oversized, decorated with an incised arrow motif, studded with tacks, and outfitted with a heavily encrusted waist-tie, it was a clearly recognizable, anatomically correct phallus, complete with glans and testicles. It even had an evocation of pubic hair in the form of a tasseled band ending in vegetable pods, with cotton ties hanging loosely at each end (27). On the floor next to it, the same sort of pods hung from a woven cotton band, perhaps some kind of dance anklet, that had once been an unsullied white (16).

There was also a mask (101). The animal-bristle eyebrows and

mustache, keyhole-shaped mouth, broad rectangular nose, and pro-
truding ear panels reminded us of a funeral mask we'd been given in
Saramaka in the 1960s, though the ears on this one were carved from
separate pieces of wood held on by fiber ties laced through a series of
holes. Its forehead had an incised motif familiar to us from illustrations
of Aluku carving, and it was lightly embellished with tacks. Strung
into ten holes bored across the jaw was a cotton fiber beard, with a
long, loosely hanging tie at each end, which supported a cluster of
vegetable pods like those on the phallus.

In the corner, leaning against the wall, we saw a circular openwork
carving set into a fragile-looking square frame (70). Next to it was a
miniature door, or so we guessed, badly worn (5). Its bas-relief carving
depicted a human figure with stylized penis and a circle of tacks
forming the face, and below it, a wriggling snake mischievously flick-
ing its tongue in the man's direction. The snake was similar to the one
on the stool but sported a line of corroded tacks rather than a carved
incision. The same snake motif appeared on two other objects—a
hoe-like instrument that could have served to rake cassava on the
griddle if the handle had been connected on its curved side, and a dark,
delicately thin hemispheric tray set into an angular frame. Finally, there
was a cluster of oversized wooden spoons, smooth from wear, which
might have served, we speculated, to scoop up cassava granules from
a griddle once they were roasted.

Taking turns at scribbling in our notebook, we tried to register
each detail exhaustively, as if by adding it all up at the end we would
know what to make of the visual smorgasbord before us. We were at
least as struck by the beauty of the pieces as by their occasional
anomalies. Sally thought back to conversations she'd had with profes-

sional appraisers in Paris and wondered how troubled she should be at the absence of a lightning-bolt first impression. She remembered having read something by a senior curator at the Louvre who declared categorically, "All attribution is based on instinct, and it's only afterward that you back it up by a reasoned argument."

It was clear that we were not qualifying as bona fide connoisseurs of the instinctual variety. Despite the occasional question raised by some detail we had never encountered in Maroon villages or museum collections, we failed to experience that spark of inspiration that would distinguish between authentic and fake. Our own notion of proof and persuasion aspired, in a temporarily paralyzing way, to "scientific rigor." We realized that our work had barely begun.

Not that we felt hesitant to speculate. Indeed, our obsession with finding some kind of "truth" was steadily building. Let's hypothesize, we said that evening over a Vietnamese meal, that the objects are exactly what Lafontaine claims them to be. In that case they represent a stupendous time capsule of masterpieces, many over a century old, with some of them bringing to light features of Maroon art and details of Maroon art history that have till now slipped by unrecorded. And if that is so, it's up to us, as specialists, to make sense of them in the light of everything else we know. Pursuing this logic, we set to work constructing life histories for the more enigmatic pieces—ethnographically informed scenarios that explained how the familiar and the puzzling could have come to rub shoulders.

What if, for example, all of the pieces had been made in the late nineteenth century in a village on the Sara Creek, a region flooded for a hydroelectric project in the 1960s that we knew only from the literature? Since Maroon religious practices are notorious for their

local specialization, couldn't that Sara Creek village have had a particular version of the *vodu* snake cult, with a more developed serpentine iconography than what we'd run into on the upper Suriname River? Over time, some of the pieces might well have broken and then been repaired by men working in a later carving style. So, for example, the canoe's original bas-relief prow-panels could have been replaced by others with the alternation of over-under ribbons that characterizes more recent carving. That would easily explain the juxtaposition of carving styles from two periods on the same canoe.

Likewise, there could have been a particular moment when standard brass tacks were out of stock in the stores of Paramaribo and carvers had made do with iron, which would have corroded over time, especially since the canoe could have been left in a garden camp at a distance from the main village, and might have stood under water for some time after a creek flooded its banks during the rainy season. That would account for both the corrosion on the tacks and the darkness of much of the wood.

The snake motif on the hoe-like object suggested a ritual use, perhaps for possession dances, so a scraping surface that was curved instead of straight would hardly have mattered. Maybe it scraped something in a rounded recipient, or maybe it wasn't meant to be used as a scraper at all. And a Sara Creek village might well have escaped the ravages of visiting field collectors, at least until, for example, a lone geologist scooped up the entire lot from the cult's aging priestess and sold it to a friend who stored it in an unused room of his plantation house on the coast.

In the end, by pushing each other to think imaginatively, and by reminding ourselves that we surely hadn't seen everything there was

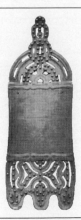

to see of Maroon religious and artistic creativity, we were able to account for virtually every artifact. It was when we put them all together that doubts began to gnaw again.

Our compulsive speculation continued, taking a slightly different path each time. What if the collection represented a mélange of objects that had simply been extensively "restored"—whether by Monsieur Lafontaine or a previous owner? Was it possible, if we looked through different conceptual lenses, to see them as fabrications created from scratch by a European schoolteacher who had mastered the carving techniques that Maroon men took a lifetime to perfect? What should we make of the unusual bone inlays? How could we account for the canoe prow's stunning beauty if it was a fake? Did the similarities we could pinpoint with pieces from museum collections and the literature argue in favor of the collection's authenticity? Or did they rather suggest that the artifacts on deposit had been copied from those pieces?

It was disquieting even to entertain the possibility that an outsider could have produced "Saramaka" artifacts of this quality. After all, wouldn't that diminish the achievement of real Saramaka artists? And on purely strategic grounds, we knew it was safer for our scholarly reputations to shy away from a negative judgment unless we had incontrovertible proof. Besides, we were not aware of any serious market for Maroon woodcarvings, which in any case are still available for purchase *in situ,* so what would be the motivation for painstakingly fabricating fakes?

We could not get ourselves to believe that the collection was "fake." But we could not yet manage to come to a decision that it was "authentic."

Battered by this mental ping-pong, we fell into bed even before transferring the day's notes to our computer. The next morning, we decided, we'd return to the collection to see what we could make of it with the help of a third expert.

Ⱥwali lived on the outskirts of Cayenne, earning a steady if modest income as a professional carver. Now in his mid-forties, he had assembled a little workforce of sons, sons-in-law, and nephews, who lived in a compound back from the road with their wives and children. Over the years they'd built a half-dozen plank houses, raised on stilts over the bare red earth. There was a standpipe for water in the shade of a cashew tree, and a couple of outdoor cooking areas stained black from wood fires. The open porches were cluttered with wooden crates, plastic washbasins, woodcarving tools, metal trunks, and sacks of rice.

Out front was an open thatched shed under a towering tamarind tree. Samples of the men's work were set out on the ground or on planks—folding stools, little owls and armadillos, Ariane rockets rising up from carved maps of Equatoria, and three-legged tables with circular indentations made to hold cocktail glasses. Awali tried to keep at least one carver working in the shed all the time, to be there when cars pulled in at the sign one of his nephews had painted: "AWALI— SARAMAKA CARVING IN WOOD."

Middle-class people from the city knew his atelier by now, and would sometimes stop in with new ideas. He'd been hard at work the past few weeks carving the sinuous openwork panels for a crib commissioned by a suburban Creole couple expecting their first child. The owners of souvenir shops would come by to order small items in bulk.

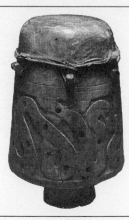

And even in this slow year there was still a trickle of tourists, mostly in rental cars on their way back to the airport.

The land itself belonged to an East Indian businessman whose own residence, a modern two-story house with tile floors and grilled windows, stood farther back from the road, just up the hill. In a common arrangement, there was a two-way flow of benefits, though little in the way of friendship or cultural understanding. The owner relied on the Saramakas to watch over things, and felt safer leaving his wife at home with the children when he stayed out late for business or personal affairs. He could also expect occasional fruit from the trees they cultivated in their compound, and a helping hand once in a while— loading cement sacks into a truck or sawing a plank or two for a home repair. The tenants built their own houses, didn't use electricity, kept the area clean, and were careful not to get in the way or make too much noise. This partnership had lasted more or less successfully for a dozen years.

Of Awali's three wives, it was Selina who spent the most time in Equatoria. To see her, you wouldn't particularly have known you weren't in a Saramaka village far up the Suriname River. The skin to the sides of her mouth and under her eyes bore raised decorative scars, cut with a razor when she was young and periodically revived by new incisions to keep them prominent. She wore a double layer of wrap skirts, tied with a kerchief and topped by a cut-off blouse in deference to the custom of her temporary home. Cooking and childcare kept her busy much of each day, but she also found time for sewing, calabash carving, and chats with others in the compound.

Selina took an interest in her husband's business, always in a spirit of conjugal deference, but it was only during the past year or so that

he had allowed her to participate. He'd shown her how to smooth down wooden objects with sandpaper, and now gave her folding stools to work on in her spare time. Once in a while Awali would take her downtown to shop or bring a child to the clinic. Then she would slip on plastic sandals and cover her wrap skirt with a cotton dress.

Awali left the compound more frequently. There were errands in the city, mostly in general stores known as *chinois* because of the face behind the cash register. There was administrative paperwork such as tax forms, work permits, and residence cards—all negotiated with the help of a son who'd been to school, but rendered official by Awali's own carefully practiced signature. And there were several-day expeditions into the forest to cut timber for the carvings. This was an increasingly difficult part of the operation as Equatoria's forested interior was gradually staked out for development projects, but the trips also allowed time for hunting, and the men rarely returned without a howler monkey or some parrots or another delicacy or two for the cooking pot. Every so often there would be a wake for a Saramaka who had died while in Equatoria. Then the men, and sometimes the women, would dress in their best, apply oils and lotions and perfumes, and head off to the dirt yard behind a house in the city for a night of eating, drinking, tale-telling, and socializing.

Saramakas brought news from the Suriname interior fairly frequently, and sometimes that led to a trip back home for Awali. A relative would die, his second wife would ask him to clear a new garden in the forest, or his aunt's possession god would demand a complex ritual of appeasement. Most recently, the teenage wife he'd taken on his last visit had given birth to a son, and he had needed to be there to supervise the baby's ceremonial introduction to the village

and offer gifts to the gods and ritual specialists who'd provided help during her pregnancy.

On our very first day in Equatoria we had visited the compound and caught up on their doings. We'd given Awali the extra copy of our art book that he'd requested, and brought Selina a bright orange blouse that Sally had hemmed up short to be worn with a Saramaka skirt. So when we stopped by the morning after our day at the museum annex there was no need for extensive formalities.

Selina had a headache and was lying in a hammock in front of their house with a rag tied around her forehead. In the yard, toddlers were being cared for by children only slightly older. Inside, Awali was talking with a nephew, helping him decide how to handle a motorbike repair. After greetings all around, we asked whether he could come with us to look over some woodcarvings we didn't know quite what to make of, and tell us what he thought of them. He excused himself from his nephew, ran a comb through his hair, buttoned up a clean shirt, and told his eight-year-old son to man the fort while he was gone. We'd already looked at some carvings together the year before, and he had found it interesting from a professional point of view.

At the museum annex, the door again opened at a slight turn of the key. Maybe the director had abandoned her campaign to instill in the storeroom assistant a proper respect for the cultural patrimony under his care. Once we were inside the air-conditioned space, Awali's eyes passed slowly from one object to the next, silently registering the room's contents, perhaps (we hoped) noting features we had missed the day before. He made clear that it was up to us to start the discussion.

Somewhat randomly, we began to make comments about particular pieces: "Look at this canoe prow. Have you ever seen gunwales that were decoratively carved like that?" (107) "I wonder how this thin tray could have lasted so long without cracking!" "Why would someone have attached the handle of this cassava rake on the straight side?"

It was some time before any of our prompts elicited a response. Awali slowly picked up the round-seated stool, staring at its base: "Funny."

"How so?" asked Rich.

"Nothing really. Just wondering."

"What makes you wonder?"

"Well, the pegs. I remember my mother's brother telling me that his father used to make stools with pegs."

"So the stool must be pretty old."

Awali didn't reply.

"Right?" Rich asked.

"Well, who knows, but it doesn't really make sense."

"Why's that?"

"I don't know. It's just that if this stool was made so long ago, you'd think it would've broken at some point."

"But then somebody would have repaired it," Sally volunteered on a positive note.

"Sure . . ."

"Well then?"

"It's just that I've never heard of *repairing* anything with pegs. I know they used to *make* things with pegs. But when you repair something like that, there'd be no reason not to use a nail. I'm not saying someone couldn't have put in a new peg. I've just never heard of it."

Awali's remarks were characteristically cautious, and carefully worded. Once, seemingly out of the blue, he offered a proverb. "They say: If you haven't seen something with your own eyes you shouldn't speak about it." We weren't sure what he meant for us to conclude.

He picked up one of the paddles. "I've sometimes had a lot of trouble finding copper tacks. There was one year when all you could find were copper-*plated* tacks. After a while the surface wore off and they got corroded. Maybe that's what happened to the man who carved this paddle." He held it, motionless, for a few seconds before going on to another object.

"I think I might have heard of gunwales being carved in Lower River villages," he said thoughtfully. "But this canoe doesn't look as if it's been used very much. Look where you'd have put your foot when you stepped in." The beautiful panel he was pointing to was relatively unworn.

We volunteered that we'd never seen cowries as big as those on the rectangular stool, but he thought perhaps he had. When Rich held up the phallus, Awali giggled. "Well? Why couldn't somebody have thought of it? You'd dance with it at a funeral the same way you do with a stick. It sure is large!" He looked away, mildly embarrassed.

Over the course of the morning there were many silences. Awali seemed pensive. When we asked him whether he thought a Frenchman could have carved these things, he laughed out loud for the first time since we'd entered the annex. "No one who's not Saramaka can carve like a Saramaka!" he boasted.

"Well, can *you* carve things in Ndjuka style?" Sally asked, following a certain relativistic logic.

"You bet! I can carve in any style you show me!" he replied with equal certainty.

"The problem," Rich said quietly, "is that the director of the museum has to make a decision one way or another. Should she buy these things? I mean, what if it were up to you?"

Awali stared into space for a minute before answering. "You used to hunt a lot in the forest," he said. "So you should understand. It's like the proverb says: If you shoot some game and it smells rotten, don't put it into your hunting sack." We read this as his most definitive statement, but weren't sure whether he was being sensitive to our own expressed doubts or voicing doubts of his own.

During one of the lulls, Sally remembered she had brought along the snapshot of Lafontaine, and pulled it out of her purse. "This is the man who's selling these things. He lives here in Cayenne. Have you ever run into him?"

Awali's brow furrowed. He examined the image, turning it to different positions as it lay flat on the palm of his hand. The years we'd spent in Suriname had taught us that it might take a while before he related the photo's shapes and colors to a visualizable individual. But even with time there was no sign of recognition.

"What do they call him?"

"Monsieur Lafontaine. Have you ever met the guy?"

Awali shook his head: he'd never seen this person.

We went back to our examination of the objects. He lifted up one and then another of the musical instruments, turning each in his hands. We discussed ritual esoterica regarding scrapers, the peculiar use of bone, and other things that came to mind, but didn't learn much. The three of us agreed that the instruments must be Creole, in any case, with some Saramaka artistry added on after the fact, as in the carved tuning pegs.

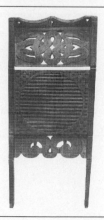

Rich introduced the issue of cost. "This dealer's asking big money for his collection. If the museum buys it, he'll be paid hundreds of thousands of francs. And we're talking *new* francs! The pieces are pretty, but the museum people need to be sure that they are what he says they are before they lay out that kind of cash."

Awali didn't pick up on this right away, but toward the end of the session he offered an allegory in the form of a teasing question: "If you're a visitor in a village and you cry out 'Thief!' who do you think they'll punish with a beating?" We weren't sure whether the outsider he imagined being bloodied was himself, us, or maybe all three. In any case, the proverb could be taken to be about the dangers of making an accusation. It wasn't necessarily about whether the accusation was grounded.

We went around and around. Some of what Awali saw in the objects added to our doubts. Other parts of the conversation, and his clear appreciation of much of the artistry, tilted us toward a conviction that features we'd chalked up as anomalies were in fact just products of individual creativity, support for the claim we had long been making in print about the central role of innovation in Maroon art.

By the time we closed up the annex, making sure to throw the bolt, we still couldn't be sure what was going on inside Awali's head. As we got into the car, he read our frustration. "Look," he said. "*You* know a lot about Saramaka art. *I* know a lot about Saramaka art. And the man who's selling these pieces must have some things to say about them. So once you've had a chance to talk to him, and the two of you have figured out what you really think, come back to see me and let's talk some more."

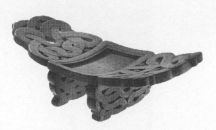

Dropping off Awali, with thanks for his help, we switched from Saramaccan to English and continued our increasingly obsessional deliberations over a Chinese lunch. We tried to elaborate the reasons for our skepticism about the collection as a whole. The lavish use of bone, which we'd never seen before, troubled us, but almost all of it appeared on the Creole musical instruments, not on objects made by Maroons. The dark patina that characterized almost every wooden object was something we'd seen on occasional pieces in museums, but it was unusual.

And there was the question of the decorative tacks. Many objects contained mixed sizes, often three different kinds, sometimes carefully graduated in a line—usages we weren't sure we'd ever seen elsewhere. Many of the tacks in Lafontaine's collection were corroded. That, too, was something we couldn't remember ever having seen on old objects. Maroons prefer tacks of copper or brass, which remain shiny over the years of normal use and maintenance. When we had taken a key and scraped a discreetly chosen tack from each of several pieces in the annex, we'd seen that the color of the metal under the corrosion was gray.

A number of the objects were absolutely stunning. In our guts, we felt as skeptical as Awali that a French lycée teacher could have produced them. But then Rich brought up the Orquesta de la Luz. Who would have imagined that Japanese musicians who didn't know a word of Spanish could produce salsa that would be all the rage in the Caribbean and El Barrio?

Sally offered semi-facetiously that if a Frenchman set out to invent a "tribal art," this is exactly the sort of thing she'd expect him to come up with—a mask, a phallus, some snake iconography, plus ample use of natural materials like fibers, bones, animal hair, and vegetable

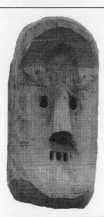

pods—all executed with dark patina plus the occasional crack and broken edge.

It was clear that a conversation with Monsieur Lafontaine couldn't help but shed light on what was going on. We felt sure that if he was producing these things in his workshop, almost any prolonged discourse on his part would somehow tip his hand. Our knowledge of dates and styles and materials was detailed enough so that some remark about alleged provenance or ethnographic context would be bound to trip him up. We could hardly wait for our meeting in August.

In the meantime, we fulfilled what we felt to be our scientific duty by sending faxes and letters to relevant specialists in an attempt to confirm a couple of possible ethnographic anomalies. First, there was the cotton-and-pod "dance anklet" (16). Its crochet stitch was the same as that used for the cotton bands that both Maroons and Amerindians wear on their calves, forcing them on so tightly that the only way to remove them, after several months of wear, is to cut them off with a knife. But the pod hangings along the object's bottom edge were like the ones that Maroons and Amerindians tie loosely onto their ankles for dancing and then undo the same evening. The object in Lafontaine's collection was like both of these—or neither one. All this raised the possibility that someone had stitched together a fixed band and a tie-on anklet to form an artifact that looked (and, in a sense, was) "ethnographic," but in fact was not known to either Maroons or Amerindians.

Sally posed our query in the form of four sketches, which we faxed to a French anthropologist specializing on the Amerindians who live in Equatoria's interior and to the president of the local Federation of

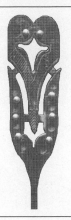

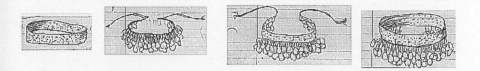

We also wrote to Jean Hurault, who was working at the time with historical Aluku/Boni woodcarvings in the Musée de l'Homme in Paris, to ask whether iron—rather than brass or copper—tacks appeared on any of the pieces in that large collection.

And we fulfilled our promise to the museum director. Before leaving Cayenne for Saint-Laurent-du-Maroni and the start of the summer's expedition, we decided to make the rounds of the shops she had asked us to visit.

One evening, dressed as urbane American collectors, we walked into the Galérie Peronnette and began to browse among the old maps and prints, the array of postcards, the handsomely framed morpho butterflies and giant tarantulas, and the facsimile editions of nineteenth-century travelers' accounts of Equatoria. We admired the gracious colonial space with its high ceiling, interior columns, and polished hardwood floor.

Eventually we noticed a Frenchwoman sitting behind an antique table at the back, penning figures into a ledger book. She gave no sign

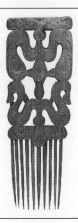

that she was aware of our presence, much less interested in it. We said good evening and asked her questions about a couple of the prints, but she said that for that kind of information we'd have to speak with Monsieur Peronnette, the owner, who wouldn't be stopping by until closing time.

"What we're really looking for," Sally ventured, "is Maroon wood-carving. Not touristy things, but authentic traditional carvings."

"We've heard," Rich added, "that Monsieur Peronnette sometimes has quality pieces for serious collectors."

"You'll have to speak with him. I frankly have no idea whether he has anything or not."

We poked around a bit longer among the framed prints. Finally, Peronnette walked in and spoke to the woman, who whispered and nodded in our direction. He came over and we introduced ourselves.

"I'm sorry. I have nothing that would interest you. I'm currently in the process of emptying out my inventory. Twenty-eight years in this place is quite enough. Nobody seems to appreciate books anymore. I plan to head back to France as soon as I can wind up my affairs."

"We've been told," said Sally, "that you have quite an eye for Maroon carving, so we thought . . ."

"My personal collection is quite modest," he protested. "And I'm not in the business of selling art. What little I own comes from a friend of mine, the only serious collector in Equatoria. *He's* the one who has the eye. But he's on vacation in France, and besides, he has just sold his whole collection to the new museum."

We understood from his tone that the conversation was over. Saying goodbye, we withdrew and continued down the street to L'Alou-

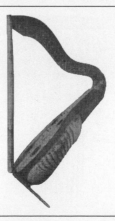

ette, a small, air-conditioned boutique on the corner. A young French-woman greeted us cordially from behind an immaculate glass counter filled with objects made from precious woods. We noticed a delicate tattooed butterfly peeking discreetly out from the neckline of her flowered dress. When we mentioned our interest in Maroon art, she unlocked a glass case and pulled out a little carving, showing us hidden panels that slid open to reveal two tiny chambers. We saw that many of the miniature boxes and other sculptures, executed in highly pol-ished letterwood, had trick openings. Their price tags ranged from ninety to three hundred dollars.

"Monsieur Revel has these made by a Saramaka carver," she offered. "He can tell you more about them if you come back in a little while. He'll be here to lock up in a quarter of an hour, but in the meantime, I think the boutique across the street has some antique paddles that might interest you."

We headed over to a jewelry store called La Pépite d'Or, where gold filigree competed with precious stones from Brazil, all crowded into little vitrines lined with black velvet. The elegantly dressed Creole clerk told us that her employer kept his paddles at home but might be willing to bring them in to show us when he arrived to close up shop a little later. She phoned to make the necessary arrangement.

Noticing a minivan marked "L'Alouette" pulling up at the curb, we crossed back and entered the store on the heels of a short French-man jangling a large ring of keys. The salesgirl addressed him.

"Monsieur Revel, these people are interested in Saramaka art."

We explained that we had lived with Saramakas and written some books about their art and culture.

"You must be the Prices," he said with a smile. I often have your

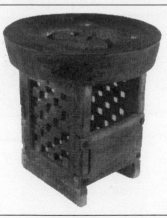

book for sale here, though it's out of stock just now. What a treat for me that you're here! I have so many questions to ask you."

For the past four years, he told us, he'd been employing three young Saramakas full time. He had set them up in a workshop on the edge of town. They were the ones who made the bulk of what he sold—tables, jewelry boxes, letter openers, and various knickknacks, all in tropical woods. "Those jewelry boxes are my bread and butter," he explained. "My star carver is Tapi. He's been making wonderful copies of some combs that I found in a little book called *Bush Negro Art*."

He reached behind the counter and pulled out two nicely carved combs, each modeled on an illustration from the book. That kind of dark wood would never have been used for a Saramaka woman's comb, but for souvenir-store items they were indeed handsome.

"But my real treasures, I wouldn't sell them for all the tea in China . . . I got them through a very good friend who knows Saramaka carving inside and out, I can't wait to show you. Sophie dear, would you bring out the paddles?"

They were stunning. All three had the dark patina we had come to associate with Lafontaine's collection, and two were studded with corroded tacks. One of them (102) looked almost like a twin of a paddle we'd seen in the museum annex. We provided the compliments that Revel was clearly waiting for, and he told us that his friend Monsieur Lafontaine would surely be pleased when he heard how much we liked the carvings. Were we aware, he asked, that other pieces from this same collection had recently been acquired by the new museum?

Revel explained that he'd been having Tapi make copies of the three antique paddles for sale in the store—always identified, he has-

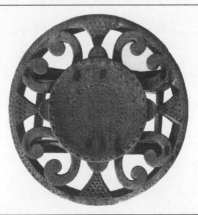

tened to add, as reproductions. He had sold the last of the copies the week before, but normally displayed each one next to its original on the wall behind the counter. The copies, he boasted, were works of art in their own right, and among the best-selling items in the shop.

"I keep going back and forth about whether to replace the tacks that are missing," he said, pointing to one of the old paddles. "What do you think? Of course, I wouldn't use tacks that were new or shiny. So as not to spoil the effect. But I really don't know what's correct. I'm so excited to meet you. I have a million questions about Saramaka. Let me just lock up here and then, if you have time of course, would you let me invite you for a drink at a nice little place down the street?"

Revel also told us that he often asked Tapi to bring back an old carving when he went to Suriname for his annual vacation, and that he now had two antique combs and a tray at home. We remembered how Awali had told us that he, too, had occasionally brought back pieces from his visits to Saramaka to sell to a Frenchman who'd requested them.

After Revel had fastened the shutters from within, we left through the ceiling-high front door. "Monsieur Price, would you be so kind as to slide this upper bolt across for me? I always have trouble reaching it."

We told him we needed to take a moment to view some paddles across the street. "Wonderful," he said. "We'll ask Georges to join us too."

The two paddles, with their now-familiar dark patina, resembled those in L'Alouette. Amid their corroded tacks, a shiny brass one stood out. The owner, displaying his connoisseurship, explained that it had obviously been added on later. Once again we listened to an *éloge* to Monsieur Lafontaine's eye for Maroon art. "He's the only one in

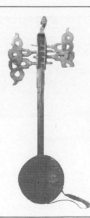

Equatoria who collects. It's his passion. He's been at it for years." After Georges had locked his own store, the four of us strolled down the sidewalk to L'Étoile.

Inside, we found ourselves in a nightclub-like darkness, and were shown to a low table by a Eurasian hostess in a satin dress slit to the thigh. "The usual?" she asked. Georges nodded.

A few minutes later a younger woman in a silk miniskirt set down four double Scotches. Monsieur Revel had already launched into a steady patter about Saramaka while his friend Georges stared toward the bar. As our eyes adjusted, we took in the décor. Toward the rear was a potted palm next to a shallow pool in mosaic tile. "Is that a real alligator?" Rich asked incredulously.

Meanwhile, Sally's curiosity was piqued by the massive canvas on a side wall. Painted in midnight black, silver-blue, and iridescent white, it depicted a nude woman, pale flesh illuminated by the moon, being whipped by a gnarly male figure standing over her in a wooden cart. Our host confirmed the animal identification and then filled us in on the painting. The owner's wife was an artist, he said, and took advantage of her husband's establishment to exhibit her work. As if he were commenting on a still life, Revel informed us that this scene was part of her "white slave" series.

Georges turned out to be a fairly laconic fellow, but he agreed emphatically when Revel said how disappointed their friend would be to have missed our visit. "He's in Europe for a few weeks with some of his collection, showing it to museums," Revel remarked.

We said we would still be in Equatoria on his return and that the museum director had promised to introduce us after we came back from our upriver expedition. "He'll be so thrilled!" Revel exclaimed.

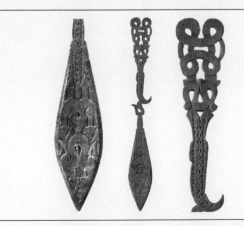

The next day, while picking up some prints at Cayenne's only custom-developing photo lab, we noticed a rack of notecards. Sold individually for eight francs, each incorporated a color print of an exotic flower, a wild animal, or another tropical image. One pictured a beautiful Saramaka peanut-grinding board with dark patina and shiny brass tacks (83), apparently dating from the same period as Lafontaine's older objects and in excellent condition. There was no identification on the card other than the name of the photographer, accompanied by the warning "reproduction prohibited."

We wondered whether this carving might help us solve our puzzle, and persuaded the salesgirl to phone her boss, a Frenchman named Durand, at his studio in Kourou, to ask about its history. After a somewhat testy exchange about who we were and why we wanted to know, carried out through the salesgirl, he told her he'd gotten it from a Saramaka named Édouard who had worked for him in Kourou, that it had been "badly rotted" when he acquired it—and that he did not want to discuss the matter further. What did that mean? Why had Durand been so short? Could he for some reason be covering up for Lafontaine?

Sally had some shopping to do, but Rich decided to see if "Édouard" in fact existed, and pointed the car toward Kourou, an hour's drive along the infamous coastal road, said to have cost 17,000 convicts their lives during its original construction. Arriving in the new urban area, Rich passed the dreary apartment blocks for lower-level employees of the launchbase, the vast Foreign Legion encampment, the pizza joints and shopping center, and the seaside villas of European engineers and administrators, before heading down the dirt road to the "Village Saramaka."

Originally attracted to Equatoria in the mid-sixties for the heavy task of clearing the forest for the future space center, many Saramaka migrants had stayed on, taking menial jobs as janitors and maintenance men at the base. Crammed together in tiny houses-on-stilts they'd built from available scraps, these several hundred men were living with the wives and children they had brought over from Suriname. In contrast to the meticulous cleanliness of their homes in the rain forest, the swampy location of this migrant village, its public standpipes, and its lack of plumbing meant that flies, filth, and green puddles filled the narrow spaces between the rickety structures.

Rich found his old friend Masini sitting on a weathered step sharing a large papaya with a neighbor. Once he had helped them eat it he asked if they'd ever heard of a man named Édouard who worked for a photographer. "That could be Makoya Anuku," Masini's friend offered. "I'll take you there."

Winding through the labyrinth of houses, ducking under clotheslines and picking their way through puddles, they arrived at the other end of the village, where Makoya said that he wasn't Édouard but he knew someone who used that name with whitefolks. He took them to Dosini, a man in his thirties from the Saramaka village of Asaubasu, who ran a little store under his house. A few shelves held bars of soap, bottles of cooking oil, and cans of sardines. A rusty refrigerator was stocked with beer and green and red soft drinks. And the rough-planked walls were papered with pinups from German magazines and blueprints of the Ariane launch pad. Dosini's brother worked nights at the base, cleaning the offices of rocket engineers.

Dosini was guarded at first, but opened up once he realized that this white man was the American who had lived just upstream from

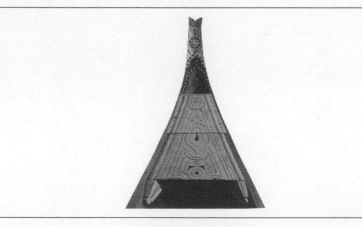

his mother's village when he was a child. When he saw the photo of
the peanut-board, he said he'd been working off and on in Durand's
photo lab for years. Once, as he was about to leave for Saramaka on
a month-long furlough, Durand had asked him to bring back some-
thing in the way of "an old woodcarving." It would have been about
five years earlier, he thought—just before the outbreak of the civil war
over there. When he got the peanut-board from his grandmother in
the village of Semoisi, the tack holes were visible but the heads of most
of the tacks were broken off. Durand had offered him 500 francs,
which he had accepted, and he hadn't thought about it since.

Rich decided to pay a visit to Durand, and eventually found him
in his modern photo lab across from the local branch of the Banque
Nationale de Paris. Durand was not unfriendly, and even asked for an
author's autograph in his copy of *Afro-American Arts*. He said he
didn't mind that Rich had sought out Édouard, and confirmed his
story, including the price. "You probably noticed that I replaced some
tacks," he said, pointing at the photo. "I hope I wasn't doing anything
wrong!" He explained that he'd given the carving as a present to a
French friend living in Cayenne and that if we wished he could arrange
for us to see it. Rich said that wouldn't be necessary.

Where did this leave us? We had stumbled on a carving that
looked very much like those in Lafontaine's collection, with a patina
and tacks that were suspect. But it had turned out to have nothing to
do with him, and its history was banal. Not only that, but we began
to see a pattern of well-to-do Frenchmen asking Saramaka employees
to bring them an antique carving or two when they returned from their
holidays, some of which they then restored, more or less faithfully. So,
we realized, there must be quite a number of "authentic" (sometimes

restored or repaired) antique Saramaka carvings in the living rooms of a certain class of people in Cayenne. Perhaps we were as wrong to be suspicious of Lafontaine's pieces as we had been to question Durand's.

Our last official act before leaving for our expedition was to send a cautionary three-page fax to the director, still in Paris on vacation, reporting the details of our investigation and our tentative conclusions. In order to hold off the sale, which we felt was the only prudent thing to do at this point, we permitted ourselves the luxury of some mild bluffing (or wishful thinking?). "We are now 80 percent sure," we wrote, "that within two months we will have the evidence necessary to convince an impartial jury that the majority of the objects were fabricated by the collector himself. In any case, our meeting with Monsieur Lafontaine next month will play a central role in our investigation."

The upriver collecting expedition in Ndjuka and Paramaka territory went without a hitch. We were kept sufficiently busy acquiring hundreds of woodcarvings, textiles, and calabashes for the museum, and writing up documentation on them, that we had little time to think about Lafontaine or his collection. But Saint-Laurent-du-Maroni, the seedy border town where we began and ended upriver expeditions, provided an atmosphere that fostered thoughts of intrigue.

Equatoria's greatest writer once called the town "a veritable Sodom." And a journalist, in 1988, described it as "four or five rat-infested streets of decaying wooden houses in the old colonial style." "The whole place reeks of decay," he wrote. "Old Creole women peer out through the windows of their crumbling structures at any stranger who

walks the streets. The open sewers are clogged with filth and drowned rats. Stray dogs paw hungrily at the rodent carcasses."

You can always count on meeting mysterious characters in Saint-Laurent. To protect the Ariane rocket base, to monitor the arms trade to the Jungle Commandos who are fighting the Suriname army across the river, and perhaps to guard against the growing influx of drugs, there always seem to be small-time intelligence men—as well as the dealers and hustlers they're tracking—hanging around. Back from collecting, we bumped into a cultured Swiss fellow several times, a pretty blond man who played Schubert and Chopin on the hotel piano and tried to get us to divulge information about Maroons—to what end we could only guess.

One night, as we were walking out of the Dominican restaurant run by the former madam of the town's largest brothel, a white-haired fellow with a walrus moustache stared so hard at us that Rich felt called upon to extend his hand and ask him, in French, "Do we know each other?"

"Didn't I know you at the Central Prison in Cayenne?" the man replied. "I was a guard there."

Rich attempted to play along. "Right. I did twenty years for killing a man."

The other people in the small restaurant looked up as Rich waved goodbye and turned toward the door. The man then asked Sally, this time speaking Dutch, if Rich hadn't served as prison psychiatrist in Cayenne. Taken aback, all she could think to say was that if he had, he'd never told her about it.

Out on the sidewalk our dinner guest, a nurse in the psychiatric ward of the local hospital, was eager to speculate on the exchange.

The man had to be some sort of agent, she assured us, looking for information—and he probably knew very well who we were. Saint-Laurent, she declared with a voice of authority, was crawling with con men and spies.

Over after-dinner drinks we discussed some of our uncertainties about Lafontaine's collection with the nurse, a Corsican with strong opinions. "If you have suspicions, you can figure they're probably true. And if he's an art forger, I'll give you odds he's queer too." She did not share our reticence to speculate about the personality of a man none of us had even met.

"I bet he's got an identity problem," she continued. "'Am I a real man? Am I a false woman? Some mix between the two?' Being gay is like forgery that way—trying to convince people you're one thing when in fact you're another." Rich rolled his eyes, but she kept going. "Believe me, I've seen that combination up close a couple of times in Italy." She giggled conspiratorially. "You know, I wouldn't mind meeting this guy."

The next morning we bumped into our old friends Charles and Monique Valmont, who worked at the Saint-Laurent hospital, and asked if they'd ever run into a man named Lafontaine. Yes, they said. Years earlier their paths had crossed when they were trying to find a mate for their pet ocelot. In those days Lafontaine had trafficked in exotic fauna and run a little zoo, they said, but what had surprised them and made them quite uncomfortable was that he clearly did not like animals.

Lafontaine's collection came up one more time while we were in Saint-Laurent. While chatting with some Saramaka woodcarvers, we remembered to ask about tacks. Had they ever heard of decorative

tacks that weren't copper or brass? Yes, they told us. There had been periods when the only copper tacks available were copper-plated. With time the finish would rub off and the iron show through. And yes, these tacks became badly corroded over time.

A month later, returning from Saint-Laurent and our upriver expedition, we checked in with the director, now back from vacation. Among the mail she had waiting for us were replies to our two ethnographic queries. Hurault reported that all the tacks he'd ever seen on Maroon carvings were either brass or copper, and the Amerindian specialist confirmed that only one of Sally's four sketches was ethnographically anomalous. That was the fourth one, the object we had seen in the museum annex.

This meant that someone, at some time, had to have sewn two "authentic" objects together to concoct a collectible. But we still weren't sure what relevance this had for the bulk of the collection, which consisted of one-piece artifacts—paddles, trays, food stirrers, and the like.

Once we'd unloaded the van and shown the director the highlights of the new collection, we asked when she'd scheduled our meeting with Lafontaine.

"I'm afraid I have some disappointing news for you," she said with a grave face. "He's had a massive coronary."

"When?" asked Sally. "How is he now?"

"It happened three weeks ago, right in the middle of the flight back from France. He's still in the hospital in intensive care. The doctors don't know if he's going to make it. It's his second one, you know."

We expressed shock, then sympathy, and finally disappointment. "We really have to speak with him about his collection if we're to get to the bottom of the case. Otherwise, we can't be sure of anything," Rich confided.

"I'm afraid it's out of the question, at least for now," she replied.

We cursed our luck, but there was nothing to do for the time being. It crossed our minds that the director might be trying to keep us away from Lafontaine. Perhaps she didn't want to find out more than she already knew. She certainly didn't seem eager to hear more about our investigation than we'd already told her in our fax.

At the same time, we felt increasingly desperate, wondering if we would ever have the opportunity to find out what was really going on. Had we been religious, we'd have lit quite a few candles for Lafontaine's recovery. But in the event, we took several days to wind up our business with the director, depositing our summer's documentation for the collection we'd made, and caught our return flight.

Back home in Martinique, we let our life fill up with other things. Rich began putting together a grant proposal for research on museums and nation-building. Sally drafted a preface for the new edition of a 1984 book. We spent a good deal of time on the phone negotiating a full-color jacket to a book in press at Johns Hopkins. For two days, we dropped everything to prepare for a major hurricane that eventually withered into a meteorological false alarm. Sally put together syllabuses for the upcoming semester at Princeton, where she'd been invited to teach in the Art and Archaeology Department. Our daughter visited. Rich slaved away to clean out a several-month accumulation

of unanswered letters. We repainted the kitchen, and made final cor-
rections on the French translation of our art book. Sally set herself up
with China ink and a pad of acetate and began making illustrations
for *Equatoria*. Rich read proofs for a book coming out with Beacon.
We hung around in the local general store for hours at a time, telling
ourselves we were doing fieldwork. We went swimming more fre-
quently than usual. We had lots of people to dinner. But no matter
how busy we made ourselves, we couldn't get Lafontaine's collection
out of our heads.

On the first of October we decided we had to go back. The
museum director had spoken, albeit noncommittally, about bringing
us down for a week or so to undo errors that had crept into museum
records between the data sheets we'd filled out in the field and the
computerized catalogue. On that excuse, we could visit Lafontaine,
whose self-presentation would, we felt sure, shed new light on the
mystery. He would presumably have recovered enough by now to see
us. And given his medical history, putting it off till next year might
well be risky.

The phone call was carefully planned in advance. Sally identified
herself to the secretary, communicated an interest in her well-being,
and inquired whether the director was in. When the second voice came
over the phone, she went through the formalities again before bringing
up the purpose of the call. We had arranged our schedules over the
coming weeks to accommodate a trip to Equatoria, and would be
happy to spend time going over the catalogue. When might that fit in
with her own plans and, by the by, how was Monsieur Lafontaine
doing these days? Well enough, we hoped, so we could stop by and
see him while we were in town.

The director listened quietly before announcing she had some very bad news. About ten days before, Cayenne had been hit by a corruption scandal that promised to spare no politician in the government. Paris had decreed that public funds in every sector be frozen until the books could be audited and a solution of some sort worked out. The generous budget she had been using to buy air tickets, equip collecting expeditions, and even run her office was no longer at her disposition. She was going to have to cut her secretary back to half time, dismiss the annex assistant, and probably move the collections into more cramped quarters. The architectural plans were on hold, and the bulldozers had been pulled off the site, leaving only a massive leveled rectangle of red equatorial earth. Needless to say, she was in no position to bring us down to correct errors in the catalogue.

Once this information had been digested and it felt appropriate to pass on to other matters, Sally reiterated an interest in Monsieur Lafontaine's recovery. This triggered another narrative of doom. "Even if you come down on your own, he's simply not in a state to see you. I don't think he will be for many months. His health is very, very, very, very fragile. It's not at all clear that he's going to recover. His doctors are quite pessimistic."

Sally had never heard the French word for "very" repeated so many times in succession and was left with a vague feeling that something other than a medical report was being transmitted. After she hung up, we talked about the possible reasons. Was the director exaggerating Lafontaine's condition in order to keep us away from him?

It didn't seem completely unlikely. Under the best of circumstances, she would have little to gain from an exposé of the objects she had bought so dearly. And now, with all the accusations in the air,

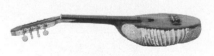

an irregularity in her acquisitions program would look even worse. As for the objects we'd examined in the annex, she'd already had Monsieur Lafontaine take them back. On the basis of our preliminary reports to her, she had decided it was too risky to get involved with the rest of the collection. Not that she had the resources to buy them now in any case. It made sense, as we thought about it, that from where she sat the issue was closed. And best not reopened. And that she would want to portray Lafontaine to us as unavailable.

The dead end had to be accepted, at least for the time being. We didn't even have Lafontaine's phone number, which we knew was unlisted. And once we'd had our conversation with the director, there was really no way of going to Equatoria on our own. We forced ourselves to focus on other projects and to think ahead to our semester at Princeton.

By late January we had settled into a modest apartment in the exclusive university community that at least one former resident has described as a country club set down in the middle of a toxic waste dump. In fact, the collegial environment was very pleasant, and we began to feel exhilarated by the intellectual stimulation that came our way daily in the form of seminars, lunches, and informal encounters with members of the Princeton community.

We didn't have much time to think about the artifacts that had so preoccupied us during the fall. But as the semester wore on, the dilemma began to resurface—through classes in which Sally raised the issue of authenticity with students, through discussions with art historians, through a three-day colloquium held at the Institute for Ad-

vanced Study, and through phone conversations with colleagues elsewhere in the country. By April, the unique richness of these scholarly resources hit us. Once we returned to Martinique, we would no longer have access to this treasure-trove of expertise and informed advice. We decided to organize a seminar.

We drew up a list of twenty-five names and reserved a seminar room with two slide projectors for a Tuesday evening three weeks later. We xeroxed our ten-page "position paper," prefaced with disclaimers about its tentativeness and upper-cased requests not to cite or quote it, and circulated copies by campus mail. We bought pretzels, chips, and Conestoga water (cherry, lime, and natural), plus two magnums of California wine, for post-seminar hospitality. We brought a pocket tape recorder so we wouldn't have to take notes during the session. To our delight, twenty-two people showed up.

Sally began by thanking everyone for coming and proposing that we go around the table with brief self-introductions. There was Professor Ulfart Vanderkunst, Emeritus, who'd been involved in the Rembrandt authentications; Marina Varetto, a junior faculty member and Renaissance scholar; Cornelia Dixon-Hunt, from the Feminist Collective; Peter J. Sherwood III, who'd recently received a Getty Foundation grant to study Roman copies of Greek statues; Meyer Hertzman, a legal scholar from the Institute for Advanced Study who specialized in media libel; Jeremy Knight and Samantha Reynolds, students from Sally's graduate course; Murray Briggs, an Islamicist we'd met at the faculty club; Robin Swann, a literary critic in the Humanities Program with whom we'd had an animated discussion about William Blake; Mark O'Brien, a recently divorced historian of China who showed up out of friendship, and perhaps evening loneliness; and a dozen others.

Rich nodded to Jeremy, sitting beside the light switch. As the room
dimmed, the door opened quietly, and in slipped Manuel García, a
friend from Mexico who had a practice in psychology but also wrote
occasionally on the arts. In New York for a professional meeting, he'd
called the day before to say hello, and we'd invited him to join the
seminar.

We ran quickly through several dozen slides, taking advantage of
the double screen to highlight similarities and differences between
objects in Lafontaine's collection and pieces we'd run into in the field
or in museum collections. Then we laid out the three ways we were
hoping they could help us. One, said Sally, was to point us to schol-
arship in the various relevant disciplines (cases, bibliography, current
debates) that we should draw on as we carried our research forward.
Another, said Rich, looking toward Manolo, was to understand the
psychological component of this cat-and-mouse investigation, which
was unlike anything we'd been involved in before. And finally, he
continued, catching the eye of Professor Hertzman at the far end of
the table, we would be grateful for advice and feedback on the moral
and legal consequences of publishing our findings once we'd satisfied
ourselves that we had some airtight conclusions.

Discussion opened in the familiar manner with a few moments of
silence, a kind of temporal no-man's-land between lecture and open
discussion, as each participant sized up the gathering and settled on
an appropriate tone of self-presentation. "What if we were to begin
with Awali," proposed Sally, alluding to the paper we had circulated
beforehand. "The Saramaka woodcarver," she added for the benefit
of those who hadn't had a chance to read it. "Does anyone have
suggestions about how to interpret his reactions to the collection?"

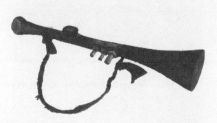

"Have you ever thought about Morelli?" asked Professor Swann laconically. Another silence. Rich asked for elaboration.

"I'm referring, of course, to Carlo Ginzburg," Swann said. Samantha Reynolds took up her four-color ballpoint, clicked it into the green she used for seminar notes, and began writing. Professor Vanderkunst scratched his bearded chin. Marina Varetto leaned forward in anticipation.

"It's a bit roundabout, but basically, it's an argument about evidence, about method, what you look for when you're trying to attribute an unsigned painting. Ginzburg develops an analogy with the techniques used by hunters. Actually, that's the only tie-in with Awali, but since we haven't yet gotten into your question, let me just try this out for a minute and see if it's helpful.

"The theory is," Swann continued, "that instead of examining the most characteristic features of an artist—Leonardo's smiles, Van Gogh's brush strokes—and seeing how they match up, Ginzburg's idea is to focus on the most trivial details. For portraits, you might examine fingernails or earlobes, for instance, things that an artist trying to copy another artist's style wouldn't think twice about, and would be most likely to get wrong, if you see what I mean. Because it turns out that each painter has a distinctive way of shaping these peripheral, little noticed details.

"Ginzburg writes about an Italian art historian named Morelli, Giovanni Morelli, who published his ideas in the 1880s under the anagram of Ivan Lermolieff. He claimed it had all been translated from the Russian by a certain Johannes Schwarze, which means the same as Morelli in German. Morelli worked a lot like Sherlock Holmes, identifying the criminal, or the artist, by looking at evidence that would tend to pass unnoticed by most people."

"The Cardboard Box, right?" It was Lisa Summerfield, a student of Swann's who had heard her lecture on Morelli earlier in the semester.

Swann glanced at the head of the table. "Am I getting too far afield?" she asked.

"Please go on, Robin," encouraged Rich.

"What Lisa's referring to," she continued, "is a long story about how Holmes is confronted with a demure maiden lady who's been mailed a severed ear in a box. He notices that it almost exactly matches one of her own ears, precisely because he's written a scientific monograph or article about the variability of human ears and how distinctive each one is, and deduces that the ear must have belonged to a very close relative of the woman. This isn't the place to go into all the details, but the more general point is that Holmes and Morelli both knew instinctively that personality expresses itself most strongly where personal effort is weakest, that little inadvertent gestures reveal people's true character more than the most carefully prepared fronts they present to the world. I hope this is beginning to be helpful."

"I'm not really sure I've grasped the point," Sally admitted.

"Sorry," said Swann. "Let me try again. Ginzburg not only showed the emergence of a new evidential paradigm at the end of the nineteenth century, citing Morelli and Conan Doyle, but he tied it in quite cleverly to the birth of psychoanalysis. You know, Freud himself wrote about Morelli's method. In fact his famous essay on Michelangelo's Moses, where he discusses it, was actually published anonymously at first. Interesting, no?

"So—and this is the point for your Samakara project—Morelli, Holmes, and Freud were all reading signs, or maybe traces, that most people let pass unnoticed or take for granted. Ginzburg spe-

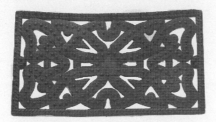

cifically contrasts this sort of 'low intuition' to higher forms of knowledge that are the privileged property of an elite, say traditional art historians. Holmes, Freud, and Morelli, with their 'low intuition,' are using a very ancient way of knowing that hunters have practiced since time immemorial. You know, reconstructing the movements of animals from broken branches, from a tuft of hair, from a few footprints. That's why I thought Morelli might interest you. If Awali's a hunter, maybe he was telling you to think something more along these lines."

Swann's monologue effectively broke the ice, and others began to abandon their initial reserve. Rosemary Kim, an anthropologist, broadened the point about the role of apparently inconsequential detail in identifying an artist's work, citing an example from British Columbia. The author of a book on Northwest Coast art, she said, had contrasted a bracelet by a Haida silversmith with a commercial copy, showing that the imitator hadn't noticed the shapes of the areas surrounding the main design elements. He'd copied the figures without paying attention to the ground. "So, it's not just the authenticity of work by individual artists that you can evaluate by these sorts of 'trivial' features," she said. "They can help with whole cultural traditions too."

Timothy Randall, a historian of modern France, added a footnote on the Ginzburg essay. "It's amusing to realize," he said with a chuckle, "that Ginzburg has published and republished that same piece without acknowledgment in various forms and places, including the journal *History Workshop* and a book called *The Rule of Three,* edited by Tom Sebeok. And I would argue that what he's characterizing is really Baconian empiricism, not some mysterious counter-tradition to 'modern science.' As usual, Ginzburg is trying to portray himself as methodologi-

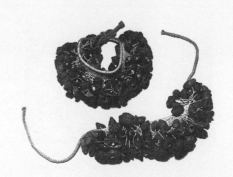

cally iconoclastic but actually turns out to be making a perfectly ordinary point."

Swann jumped back in to argue that, whether a piece is published anonymously or under a pseudonym or without acknowledgment of previous publication, it's interesting to conceptualize plagiary as a mirror image of forgery. "In plagiary, you're pinning your own name onto someone else's work. But in forgery, you're pinning someone else's name onto your own work."

"That's neat!" said Rosemary. "I never thought of it that way."

A member of the German Department then offered some comments on the etymology of the word "fake," pointing out that German *fegen* contains an essential ambiguity, not only a "bad" sense of deceiving or betraying, but also a "good" sense of improving and cleaning up.

"English 'forging' is like that too," added Murray Briggs. "Both positive creativity and the taint of the counterfeit. All this makes me think of Tony Grafton's lectures here a couple of years ago, where he emphasized the allure of forgery, how the desire to forge can infect almost anyone—Erasmus forged texts, Michaelangelo forged sculptures. Grafton showed a slide of the title page of a classic treatise on forgery whose motto was *Mundus vult decipi*—The world wants to be fooled. And he concluded something to the effect that the human mind nourishes a deep-seated desire to be taken in as grandly and thoroughly as possible. Part of the point was that there's a powerful attraction on both sides—to commit forgery and also to be taken in by it."

Samantha raised a hand and was given the floor. "I just wanted to say that I think it's interesting that people who write about fakes and art forging get involved in things like pen names and anonymous

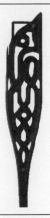

publishing and that kind of thing. I mean, what Professor Swann was talking about, like that something was translated from Russian when it really wasn't. So, I wanted to ask you, Professors Price, how do you feel about your own writing on the subject? You said in the paper you circulated that you were thinking about changing people's names, and maybe even distorting some of the story so it could be read for the ideas and not as an accusation, but I don't know, I'm sort of not sure that would work."

Professor Hertzman broke in to save his realm of expertise from trivialization. "What this young lady is bringing up is quite relevant. I would point out as a further example that Clifford Irving wrote the story of Elmyr de Hory, the art forger—allegedly as de Hory told it to him in friendly conversation when the two of them were neighbors in Ibiza, not long before he went on to the autobiography of Howard Hughes. That, as many of you must remember, ended in a libel conviction on the basis of evidence that Irving had never so much as met Hughes."

"But that's just a footnote," he continued. "What I really wanted to say was that one key to all this, from a legal standpoint, is whether or not you mix factual and fictional claims. And whether the characters you describe in your writing are identifiable—even if it's only to themselves. In other words, if you say enough that's true about someone so they can recognize themselves, and then add in other things that are demonstrably untrue (presumably offensive—otherwise they wouldn't be bringing it to litigation), you're playing with fire from a strictly legal standpoint.

"In practice, though, it tends to get pretty complicated. I once advised a young novelist who'd created a rather unattractive character

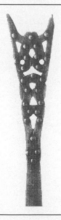

on the model of someone he really knew—a professor who was going to Berlin on sabbatical and couldn't take his secretary along, but also didn't want to give back her salary to the university. So he proposed to split it fifty-fifty with her, except that she got a little extra because she was the one who declared it on her taxes. They referred to it as their Big Brown Bag, because she gave him his part in cash—actually in a brown paper bag!—when he got back. The professor had confided in the novelist, who was a friend, at a cocktail party.

"So the whole thing was in fact based on a real-life scenario, but absolutely everything except the scam itself was altered—I think the professor was changed from an old man to a middle-aged woman, and so on—so the only basis the original professor could have used to sue over the publication of his little caper was if he proved that he had, in real life, cheated his university out of a secretarial salary. Which of course he wasn't about to do. Like any branch of law, publication libel tends to get enormously convoluted when you deal with actual cases, and there are tremendous gray areas that make it hard to predict an outcome ahead of time. You really have to reason each case out on its own idiosyncratic terms."

"Excuse me, Meyer," said Rich. "Just some bookkeeping. I've got Professor Vanderkunst, Peter, Cornelia, Mark, Marina, and Chris. Anyone else?" He'd been jotting down names as people around the table indicated their wish to speak in art auction fashion, by a discreet nod or an upraised index finger. "Manolo? Okay, thanks, I think I've got it. Does anyone want to jump in here on what Meyer's been saying? No? Well, I for one, would like to come back to the legal issue, but let's go down the list first and get some other thoughts on the table."

Professor Vanderkunst took the floor in a gravelly voice. "I wish to return, if I may, to what Professor Swann was saying. Is it not a possibility . . ." He took a moment to find the English expression he was searching for. "Is it not possible that you are barking at the wrong tree? My own involvements, in a very different realm admittedly, lead me to be stricken that most frauds in the history of art do not become discovered by the sort of systematic analysis you propose at all. Whether the features you are examining are central or marginal—that is of course interesting to think about, but more frequently, if you look at the historical documentation, you find that it occurs by some completely casual error that absolutely forces the realization upon you, some bizarre and unforeseen circumstance that highlights the discrepancy."

"Could you be more specific?" asked Marina Varetto.

"There are any number of examples. Van Meegeren is undoubtedly the best known. But we could also come back to de Hory to make the point. De Hory managed to paint hundreds—maybe even a thousand—Picassos, Modiglianis, Dufys, and others that were picked up by museums and galleries in Paris and New York and Tokyo. He got away for twenty or thirty years with it, until a French auction-house employee, routinely cleaning off some excess varnish from a Vlaminck about to go on exhibit, happened to notice some blue paint from the sky coming off on the rag. That is how he was discovered."

Professor Vanderkunst paused for a sip of water before continuing his exposition. "Van Meegeren's story is even better. He succeeded to paint fake Vermeers that brought millions of dollars and were hung in museums all over Europe. And then, by pure chance, Hermann Goering took a fancy to one of these Vermeers and bought it from a dealer

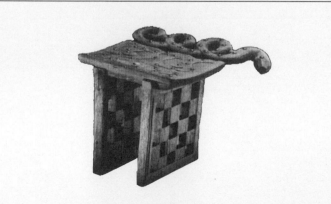

for a million dollars worth of other paintings the Nazis had stolen
from occupied Holland.

"When the war ended, the Allies found this previously unknown Vermeer in Goering's collection, and the trace led them back to van Meegeren, who was put on trial for *selling* to the Germans a Dutch national treasure. They accused him of collaboration and he faced the death penalty. So, at the trial, he shocked the art world by proving—with the greatest difficulty, but he was eventually able to do it—that he had actually *painted* the canvas, as well as several other famous Vermeers. If I am not mistaken he accomplished this proof by painting a Vermeer in front of the jury! The point is, and here I am agreeing with Professor Swann, perhaps you need a little luck. Perhaps you should be looking at things other than formal details. Perhaps there are other kinds of clues."

"I really get annoyed at these kinds of stories," said Peter Sherwood. "Nothing personal, Ulfart. But it's simply not true that most art historians were fooled by the work of de Hory or van Meegeren. Experienced observers discounted van Meegeren's work from the very beginning. Why do people have such a need to repeat that tawdry story, insisting no one can really tell? It's an affront to the very notion of connoisseurship."

"I've got to step in here," announced Cornelia Dixon-Hunt. Sherwood rolled his eyes upward. He knew what was coming.

"What you never acknowledge, Peter, is that there's a difference between privilege and knowledge. This is just the kind of situation where the class struggle plays itself out absolutely transparently. The old-guard art establishment feels it's got to defend its aging fortress, and it can only do that by refusing to allow any questioning of its self-selected members' pronouncements."

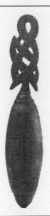

"I must say," she continued, "I had a feeling this issue was going to come up, so I came prepared. I've got an article here from the *New York Times,* with some incredible passages by John Russell.

"Listen to this: 'I hate to say it, but a lot of people love fakes . . . And those same people,'—you can tell who he means—'often love fakers, too, and they see them as the lone riders of the art world. Fakers, they think, are sexy, mischievous, insubordinate outlaws, who like nothing better than to puncture the stuffed shirt and watch the sawdust run out. Fakers are credited with energy and bounce, daring and dash, no matter'—this part's where he shows his true colors—'no matter how often the facts prove them to have been second-rate wretches who found relief in living a lie.'"

"Excuse me," said Professor Vanderkunst. "I do not wish to interrupt your presentation, but let me just remark that, during the trial of van Meegeren, he actually became a kind of national hero in the Netherlands! Many people were delighted that someone had been able to fool the authorities."

Cornelia nodded and continued to read from the John Russell clipping. "'To an experienced observer, the general run of fakes give off a powerful and disgusting vibration. It is only very rarely that a fake can deceive an informed observer. There is always someone who can tell the difference between truth and falsehood, just as there is always someone who can tell at a glance what is wrong with a horse, a plant, an automobile or a balance sheet that is not what it is claimed to be.' He even tries to bash Walter Benjamin! He says Benjamin 'led whole generations astray' in trying to demystify the value of original works of art in the age of mechanical reproduction.

"And he keeps coming back to the solidarity between forgers and

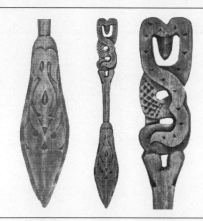

the rabble. (Okay, Peter, just let me finish. I'm almost done, and I really think you should listen.) He talks about forgery as coming from 'pure mischief—the wish to make trouble, to thicken the stew, to make other people look silly. And then there is the hatred of art, the blind malignity that is more widespread—often on an unconscious level—than is generally supposed.'"

"It's all High Culture," she summed up, "Real Culture versus low culture. Us against them. The system needs fakes in order to maintain the authentic. And the gatekeepers, the men who pass judgment, are always the same."

"Part of the problem," said Palmer Wright, who was completing a dissertation on *Guernica,* "is the absolute arrogance of the class that passes judgment. When I was in London at Christmas I went to see the British Museum's show on fakes. They did a really interesting catalogue that I decided to bring in." He held it up. "I'd like to read you what the great art historian Abraham Bredius wrote in 1937 about van Meegeren's most famous 'Vermeer,' since it throws a certain light on John Russell's comment about fakes giving off a disgusting vibration that informed observers can always sense." He cleared his throat and began to read.

It is a wonderful moment in the life of a lover of art when he finds himself suddenly confronted with a hitherto unknown painting by a great master, untouched, on the original canvas, and without any restoration, just as it left the painter's studio! And what a picture! Neither the beautiful signature . . . nor the pointillé on the bread which Christ is blessing, is necessary

to convince us that what we have here is a—I am inclined to say *the*—masterpiece of Johannes Vermeer of Delft.

"But then listen to what one of Bredius's successors writes in the catalogue about van Meegeren's work, once everyone knows it's forged:

> Among the most conspicuous characteristics are heavy-lidded eyes with raccoon-like shadowing, overly fleshy lips and noses, square-tipped wooden-looking fingers, and fragile, tiny wrists. The bag-like garments hung over the figures do not even succeed in disguising the faker's lack of ability in achieving correct anatomical structure and volume . . . In the *Christ and the Adulteress* Jesus looks somewhat healthier than in most Van Meegerens, but a blood transfusion would do no harm.

And so on. My point—and this is just to support what Professor Dixon-Hunt was saying—is that the same connoisseurial arrogance can lend an air of authority to both right and wrong conclusions. Given the credentials, you can say yes or no to a painting's authenticity, and people will take what you say as God's truth. And without even skipping a beat, art historians are capable of turning their assessment upside-down once they know . . ."

Rich broke in. "Discourse aside, what's really interesting to me about this kind of case is how completely our vision changes once we think we know whether something is real or not. Once we know, on independent evidence, that something's fake, we can't imagine how anyone could have thought it was authentic."

Sally noticed that Cornelia was gearing up to reenter what was threatening to turn into a Sherwood/Dixon-Hunt debate of the kind

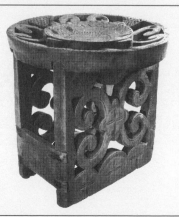

most of the people present had already witnessed somewhere on campus. She quickly gave the floor to Mark O'Brien, the next person on the list.

"Well, I'm really out of my realm here," Mark said deferentially. "So I'll be brief. I just wanted to mention a detail of Chinese art history that shows how complicated even the distinction between 'fakes' and 'authentic works' can be. Someone who's more of an art historian than I am could supply the specifics, but essentially it's quite simple. Some Chinese paintings are executed on paper made from mulberry bark, which has two very thin layers. I guess it's kind of like Kleenex or toilet paper—so thin that a skillful hand can apparently peel them apart and produce two essentially identical paintings out of one. Which one's the original? Or can you have two originals? I just wanted to throw that out for what it's worth."

"Could we come back to the implications for an interest in deception?" suggested Chris Walters.

"I don't think we should pass so quickly over what Mark brought up," protested Marina Varetto. Sally knew she'd had her eye on Mark since his divorce, and imagined her secretly chalking up a point here for figuring out a supportive comment. "I think Mark's example is just enormously suggestive for that whole murky area between 'fakes' and authentic works. As his comment shows, the methods of exploiting it are specific to particular cultures and historical periods, but if you add them all up there are really a lot of subtle ways for players to maneuver if they're motivated. You can 'restore' a ruin deceitfully. You can 'flatter' a pedigree. You can fiddle an attribution. Even perfectly 'authentic' artists can 'forge' their own work—Dali, for example, used to sign blank sheets of paper and give them to his dealer. And we've all heard

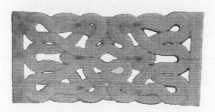

the anecdote about Picasso boasting that he could make fake Picassos as well as the next guy."

"That's something Rich and I need to think more about in anthropological terms," Sally commented, jotting a note in spite of the still-turning tape recorder. "The whole gamut of ruses that've been devised in Africa is fairly well documented—and of course there's María Martinez's generosity in signing her name on pots made by other Pueblo artists. But the marketing of 'ethnographic' art from a lot of cultures—including the Suriname Maroons—is new enough so that we sort of have to think from scratch about the games that people might be playing. In a way, that's the whole key to what we're dealing with in Lafontaine's collection. Excuse me, Chris, I know you're next, but I just wanted to slip that in as a reminder that the Lafontaine case is still alive and well here."

Chris Walters came back to the potentially tainting implications of an interest in deception, with a footnote to the Clifford Irving–Howard Hughes story: "I can't remember where I read about it, but I know that the person who wrote the main book about van Meegeren was an Irish aristocrat named Lord Kilbracken and that he shows up as a character in Clifford Irving's book. In the book he comes to Ibiza and has some kind of interaction with de Hory. In fact, Kilbracken is supposed to have known de Hory in real life. It seems to me that people who start writing about this demimonde have a tendency to somehow get drawn into it, almost just by association."

This contribution didn't elicit a follow-up, so Rich gave the go-ahead to the next person on his list. "Manolo, what do you make of all this from a clinical point of view?"

"It's a tough one. But I do have a few little ideas." Manolo glanced quickly at his notepad.

"I don't know if the objects are real or not, though it seems to me maybe you're protesting a little too much that they *can't* be fake. I tend to see what's going on between you two and Lafontaine as a process of seduction. He's pulling you in, making you part of his operation, forcing you to join him as agents in the exploitation of his collection—whether or not the stuff is real, but the whole thing would get especially interesting psychologically if there's some kind of deception involved. Obviously, it's your knowledge of Maroon art that makes you his ultimate prey."

"What do you mean, 'obviously'?" interjected Briggs, looking irritated at the use of this word in an argument that he was apparently not following.

"Sorry," Manolo said, "I'll try to be clearer. Essentially, it's because the Prices *know* so much about the art, but even more because—unlike most people Lafontaine deals with—they *care* so much about it, that they're so perfectly suited to be Lafontaine's accomplices. The museum director's important to his operation too, because of her position and local visibility. So he's pulled her in, getting her to provide both money and public valorization of the collection. We could also do a little analysis of the fact that all his best friends are holding cards from his deck. But the way he's appropriated Richard and Sally is especially interesting, psychologically—getting them to lie awake nights thinking up ethnographically correct scenarios about snake god shrines and flooded villages and the like. All of which supplies an authoritative, not to mention highly exotic, set of provenances for his pieces.

That's useful to him whether the pieces are the real McCoy or totally shameless fakes."

The discussion went back and forth over the "seduction" hypothesis, touching on Anthony Grafton's remark that forgers and critics are "entangled through time like Laocoön and his serpents." Eventually it got back to legal issues. Jeremy brought up an article in *GQ*—which, he was quick to explain, he'd run across that morning in his dentist's waiting room.

"A man named Robert Trotter was selling nineteenth-century American folk art that he produced in his studio. The paintings were always unsigned, and they were going for several thousand dollars each, so he was making a tidy profit. After a while, his greed overcame his caution and he decided to sign one of them. He couldn't resist using a name that was fetching upwards of $350,000 at the time, and that's when he stepped over a legally critical line that ended him up in jail. He went from stealing artistic styles to stealing a person's name, and that made all the difference. According to the article, he became the first American in history to go to jail for art forgery."

Jeremy's report sparked a discussion of the importance, in forgery cases, of the kind of art in question. Artistic traditions where names and signatures had less importance, volunteered Palmer Wright, carried different legal status from most paintings and sculptures in art history textbooks. Professor Vanderkunst noted that "primitive" art was a limiting case in this regard. Gesturing at the carousels of slides we'd shown at the beginning of the seminar, he advised us with some feeling, "You must never, never underestimate the absolutely total disdain that mainstream art historians have for the kind of art that you study."

Professor Hertzman then pointed out that our case was taking place in France, and that the relevant laws there were far from identical to those in the States. "I'm not up on exactly how it works," he said, "but I believe that anything is permitted between private parties. Jeremy's case hinged on whether the art was signed. I believe that in France the legal watershed is whether it's sold privately or to the state. If I'm right on this and if your dealer is also a forger of some sort, his sales to his friends—no matter how duplicitous—would be perfectly legal, but his sale to the government museum would constitute fraud."

John Murphy, an ex-journalist turned anthropology student, came in at this point to ask about the relevance of "the JM imbroglio." Janet Malcolm's book *The Journalist and the Murderer,* he explained, had raised a messy and really quite fascinating tangle of legal and ethical issues through a critique of the journalist Joe McGinniss's book about the convicted murderer Jeffrey MacDonald. Various commentators, including Jessica Mitford, had questioned Malcolm's motives in writing about the case, given its similarity to previous charges against her own writing by the psychiatrist Jeffrey Masson. Malcolm's book had accused McGinniss of transgressing professional ethics by instrumentally befriending his subject, pretending to believe in his innocence, and hiding the fact that he was portraying him as guilty. According to Malcolm, McGinniss had stepped over the thin line separating permissible professional relations between journalist and subject (which always involve self-interested behavior) from outright duplicity and betrayal.

John went on to explain that the earlier suit, still under appeal, had accused Malcolm of casting Masson in an unflattering light by attributing to him libelous quotes that she had fabricated herself. Her

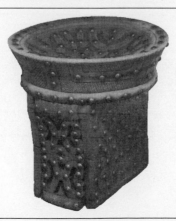

defense focused on the difference between spoken utterances—by nature fragmentary, repetitive, and often incoherent—and the written word, which captured the meaning and tone of speech in a form that was digestible to readers. Slavish transcriptions of the syllables on a tape recorder, she argued, would come out as gibberish on a published page. And it was common practice to smooth out contradictions, digressions, repetitions, and assorted other zigs and zags of ordinary speech.

Malcolm had written, among other things, that Masson boasted he was going to expand the Freud Archives into a place of "sex, women, and fun." And on the tapes she possessed, he could indeed be heard declaring that he foresaw the archives as a place for great parties where the men would "live it up" and "pass women on to each other." The legal issue was whether her four-word "quotation" was a libelous misrepresentation of what he actually said.

What might this have to suggest, John asked, on the one hand about how we should conduct ourselves with Lafontaine if we got a chance to talk with him, and on the other hand about the constraints on publishing the story, including Lafontaine's commentary, if he turned out to be forging the pieces in his collection?

Several of the seminar participants had read Janet Malcolm's two-part article in the *New Yorker,* and Professor Hertzman was able to supply a summary of the reactions to it that had been published in a special issue of the *Columbia Journalism Review.* After a lengthy discussion, there was a general consensus that normal friendliness with Lafontaine, if we eventually got to meet him, would not overstep ethically acceptable boundaries, as long as we didn't suggest to him that we were prepared to authenticate his claims about provenance.

And the standards for academic—as opposed to journalistic—writing,
everyone seemed to agree, required fidelity to meaning and tone, but
not on the level of word-for-word transcription. Rosemary brought
the conclusion home to anthropology: "If we were held to the stand-
ards of evidence that Masson's suit is trying to impose, I don't see how
the discipline could even exist."

Peter Sherwood, looking increasingly irritated as the discussion
roamed further and further from his own realm of expertise, finally
found a way to bring things into his home territory by mentioning
another *New Yorker* series—the intrigues involving a "fledgling art
dealer" from Indianapolis named Peg Goldberg and some extraordi-
nary Byzantine mosaics. That in turn, he added, brought to mind the
Cellini Cup, which would perhaps be relevant to think about in the
present context.

At a seminar held in the Art History Department, he proposed,
there was little need to rehearse the story of how this exceptional vessel
had first earned its fame as the work of the Renaissance artist Ben-
venuto Cellini, how it had later been attributed to a goldsmith from
Delft named Jacopo Biliverti, and how it had recently been exposed
as a fabrication concocted in the nineteenth century by a German
locksmith's son, the notorious Reinhold Vasters. "I won't bore you
with the details," he said, turning to us. "But I think if you read Joseph
Alsop's account of the investigation you might understand a little
better what goes into a responsible expertise. You've got to be able to
back it up by laboratory results, and the research can go on for decades
before a definitive verdict is reached. How can you talk about making
an attribution by chipping casually away at corroded tacks with a key
from your pocket? Where are the archives you'd need to consult for

written documentation? How about X-rays and microscopy and ultraviolet radiation? If, as you claim, there's no infallibility in the 'eye' of the connoisseur, what kind of 'science' do you have to offer that will take its place?"

Rich supplied the answer that would have been obvious to any anthropologist. "What you're saying is true, Peter, but we have one advantage that allows us to short-cut all that. Unlike Renaissance scholars, we can talk—if all goes well—with at least one of the principals in the case. And if we do manage to talk with Lafontaine, there's every reason to believe he'll say something that will allow us to decide what's really going on. Is he a legitimate dealer who's amassed a spectacular collection through a combination of luck and astuteness? Is he an obsessive, gifted forger? A tinkerer who simply indulges in excessive restoration and repair? Maybe an accomplice to a forger, say from Paramaribo? Or maybe he's just a more or less innocent fence. We're quite confident that talking to him would turn up whatever clues we need. As anthropologists, we've always taken the position that talking with people is key."

The seminar eventually wound down with some diffuse back-and-forths, and we adjourned to the wine and plastic cups. It had been a heady session.

We walked back to our apartment with Manolo, who was spending the night. "There's something else I want to tell you about this whole business," he said. "I didn't want to mention it in the seminar, but it's important." He took a moment.

"I want you to be much more careful than you think you need to

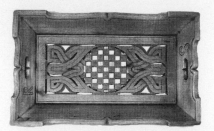

be. If you do get a chance to see Monsieur Lafontaine, I think you should arrange to do it in a public place. Everything you've said about him suggests the possibility that he's deeply disturbed, that he's emotionally unstable and quite possibly dangerous. Given what you're doing, you could easily tick off a violent episode. Let me tell you a little story.

"A couple of years ago, the Church sent me a patient for evaluation—a policeman who said he'd had a vision of the Virgin and wanted to become a priest. I had several sessions with him, and got more and more intrigued with what was going on each time I saw him. It became a kind of obsession. I knew that I should stop. Everything in my training, everything in my twenty years of clinical experience told me that I knew enough to come to a conclusion for the Church and to suggest that the man needed treatment. But I couldn't stop myself from pushing on it.

"One day I had him take me to the place where he'd had the vision. It was in a church. He was in his uniform, with his badge and everything. He took me straight to the altar and started staring and staring right up the skirts on a statue of the Virgin. When I spoke to him, he flipped. He just wasn't there. He had gone into the painting on the altarpiece. He couldn't tell inside from outside any more. And then he pulled his gun and began waving it around, shouting and gesticulating. I've never been so scared in all my life.

"I remember how much I was shaking when I told Estrella that night. And I still feel myself shaking every time I think of it. I keep telling myself, 'You should have known better.' But something inside made me keep pushing.

"That's why I'm afraid for you. I can see that you've got that same

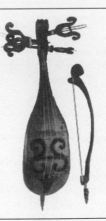

need to get to the bottom of it. And if the man does turn out to be like that, you could really be at risk."

We were sobered by his story and promised to be careful. But we weren't convinced that his policeman was as related to our art dealer as he imagined.

The next weekend we drove into New York to meet Stewart J. Wilson, a distinguished museum anthropologist who had agreed to view our photos and see if he could give us any advice. After an hour of knocking around different aspects of the puzzle, he suddenly asked us, with some feeling, if we'd thought about why we wanted to continue our investigation. Hadn't we already stopped the sale and fulfilled our professional responsibility by sharing what we knew with the museum director? And if we did find out more, what did we expect to be able *do* with that information? Aren't there some things it's wiser not to know about?

As he was leaving, he thought of a book we might want to consult. "I think it was published in the twenties and it's by a French archae-ologist, about forgeries and fakes. The author has some kind of aris-tocratic-sounding name like Pradelles de la Tour or some such—and the title is something like *La fraude archéologique dans la préhistoire*."

In the Marquand Art Library, we tracked down the volume Wilson had suggested: A. Vayson de Pradenne, *Les fraudes en archéologie préhistorique, avec quelques exemples de comparaison en archéologie générale et sciences naturelles*.

The first part of this nearly 700-page tome was devoted to famous and infamous frauds in prehistory, each laid out according to the same

series of phases: (1) "the state of scientific knowledge and the general mentality of the epoch at the time and place of the fraud"; (2) "the origin, nature, and development of the fraud"; (3) "the discovery of the fraud"; (4) "the development of the controversy"; and (5) "the end of the affair."

But what caught our special attention was the author's ruminations on the psychology of fraud, focused in turn on each of "the mental types that constitute the human elements of fraud: the forger, the principal dupe, the discoverer, the scientific public, and the lay public."

Regarding the forger, the text went into some detail on "mythomania," the fabrication and belief in fabulous stories to go along with the material fraud, concluding that its principal motives are "vanity, spite, and cupidity—attracting flattering attention to oneself by means of a sensational discovery, deceiving someone for the thrill of witnessing his foolishness, and gaining money. Such motives, capable of influencing any normal person, are what drive a mythomaniac to fraud." As for the forger/mythomaniac's belief in his own stories,

It is often said that in order to fully persuade others, one must be fully persuaded oneself. But in fact it seems that what it takes is, rather, an ardent *desire* to persuade. Such a desire is often encountered in sincere and honest people—hence the dictum. But it is also encountered at least as much, if not more, in mythomaniacs, which probably explains their success.

In the ordinary liar there is usually an element of fear, a hesitancy engendered by prudence, which undermines the power

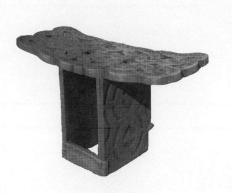

of persuasion. But the mythomaniac deploys, in his lies, a fearless ardor which can easily be mistaken for sincerity.

Next applying his analytical acumen to the scientific dupe, or mark, the author analyzed why it is so difficult for him to "see" the fraud: "In most cases, what is involved is less a total absence than a specific and momentary lapse—a local anesthesia, if you will—of his critical faculty." What, then, are the motives behind this lapse?

It is *emotion* that paralyzes the critical faculty—or rather, blocks its access to a particular domain . . . especially the desire to reaffirm some set of personal convictions . . . Among most men there are feelings that override the desire to find the truth, and this holds even for men of science and for scientific truth . . . The desire to *confirm a personal viewpoint* can produce in certain minds, which might in other respects be quite gifted, a more-or-less complete obliteration of the critical faculty.

Some of the author's most inspired passages were devoted to dissecting the relationship between the forger and his dupe. Drawing on a hunting metaphor, Vayson explored the way the forger tries to learn as much as he can about what the dupe really wants.

In the arts of both fishing and trapping, the choice of the bait is crucial. It must conform to the appetite of the animal to be captured; with the right bait, the crudest trap can become excellent. Likewise, if a forger manages, whether by calculation or mere luck, to come up with an object that confirms some pet theory of the dupe, he will have every chance of

succeeding. Sometimes the dupe, even without being specifi-
cally targeted, will rush to be taken by a well-chosen bait.

The passage ended with a specific reference to techniques for hunting
birds in the French countryside. "Larks fly from afar," it said, "to
reach the mirror."

Rushing to our French dictionary, we found the lark-and-mirror
allusion without difficulty. A *miroir aux alouettes* was defined as (1)
a "device composed of a moveable panel with little mirrors, intended
to turn and shine in the sun to attract the birds" and (2) "that which
deceives, that which fascinates." Our French-English dictionary trans-
lated the term as "decoy" or "lure." Feeling that we were on to some-
thing, we decided to pursue the matter further, scribbling out notes on
mirrors (as reflections, as copies, as illusions, as flattering lies) and
searching out associations for the word "lark." Our English diction-
aries reminded us that as a verb "lark" means "to play a trick on
someone; to have fun; frolic; romp" or "to behave mischievously; play
pranks." And that as a noun it means "a frolicsome adventure; a spree;
a merry, carefree adventure; innocent or good-natured mischief; a
prank." The *Oxford English Dictionary* offered a typically erudite
observation on its origin: "The ulterior etymology is unknown: some
of the OE. forms, and the ON. *lávirke* (only in the Edda Gloss, and
perh. from Eng.) lend themselves to the interpretation 'treason worker'."

Vayson concluded his text with a plea for vigilance:

Let us hold onto the desire to combat fraud; let us learn from
the past; let us be steadfast in the conviction that it will never
know important or long-lasting success. But let us not suc-
cumb to the illusion that it will disappear from the face of the

earth as long as there are men. And let us console ourselves for its unpleasantness by acknowledging its sometimes useful role in the growth of human knowledge.

Good news arrived in the mail: fellowship grants that would allow us research trips to Equatoria.

But first we flew to Paris for a conference. There we met with the anthropologist who was serving as official advisor to the museum director, and outlined our findings to him over coffee. His advice, though motivated perhaps by closer familiarity with the situation, echoed that of Stewart Wilson. Wouldn't it be better for everyone, he argued, if we just let the matter drop? The director now had the information she needed, and negative publicity about the museum's collection could be distinctly counter-productive at this stage. Besides, he insisted, wasn't this all pretty tangential to the comparative museums project we were supposed to be working on?

But no one's advice, no matter how rationally persuasive, could have stopped us at this point. We had to push ahead. For the first time we would be working independently of the museum director, exclusively engaged in our own research. We called to tell her we might be coming to Equatoria, but did not mention that we'd be seeing Lafontaine. The same day, we also called Monsieur Revel and got Lafontaine's unlisted number.

Sally phoned to ask if we might visit in early August, two weeks away. The voice on the other end of the line had a strong Mediterranean

accent, and once Sally identified herself it became distinctly edgy. Unfortunately, Lafontaine said, he'd be in Europe then, to sell objects that he had stored in Berlin and France.

He made a point of letting her know that "not more than five minutes" had passed after the museum turned down the objects on deposit before he sold them to another buyer—in Equatoria. It was purely out of supportiveness for the museum project, he said, that he had offered them for sale there; he certainly had no lack of eager buyers to deal with. Apropos of the objects he was taking with him on his upcoming trip, he was quick to specify that "My papers, as always, are 100 percent in order." Sally had not suggested that they weren't.

When she asked specifically about the Saramaka canoe prow, mask, and phallus, Lafontaine replied that "of course" they had already been sold. "But as it happens," he added a moment later, "I do have a second mask, and I may even be getting in a third. The second isn't as old as the one you saw, but it's very interesting—it has a triangular form and is inlaid with bone." The first one, he said, had come from French Guiana about nineteen or twenty years earlier; the second was from Suriname and of more recent date.

In the course of the conversation, Sally mentioned that there was growing interest in Maroon art in the United States. "You don't have to tell me that!" he countered. "I'm very aware of how much people want to buy these things." She expressed disappointment that we couldn't meet, gave him our phone number, and said we looked forward to seeing him sometime after his return from Europe. "Perhaps," he said, "but you should know that my doctors give me one chance in two of not returning."

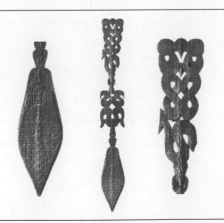

Our appetites whetted, we decided to move faster and more decisively. The next day we reserved seats on a flight a week away. We called Lafontaine a couple of days before we left, saying that another research project was bringing us to Cayenne, and asked whether we might find time to get together. More nervous-sounding than ever, he alluded to a trip of undetermined duration that he'd be making to the interior of Equatoria, and avoided making any commitment.

It was nevertheless a polite, mutually flattering conversation, and he invited us to call him upon our arrival. If he happened to be there, he said, he'd be willing to meet us. Again stressing his fragile health, he said he was thinking about leaving Equatoria definitively once he sold off the last pieces of his collection. He had very little left, but there were still two or three trays, "very much like certain ones in your book," he remarked, that we might be interested in seeing.

"Just out of curiosity," he added before saying goodbye, "what exactly is the reason you wish to see me?"

Sally told him that everyone we'd talked to in Cayenne had mentioned his name as *the* expert in terms of collecting Maroon art. Since he and we shared a love of the same thing, she suggested, it seemed appropriate that we should get to know one another.

He protested that it wasn't much of a distinction to be the best in this field, since there were no other serious collectors in Cayenne, and that, set next to our own expertise, his was less than nothing. "And, by the way, if it's not prying," he went on, "might I be so bold as to inquire about exactly what business it is that is bringing you to Equatoria?"

Sally replied with an allusion to ongoing Saramaka research and mentioned that we had a book we wanted to present to him. He

boasted again that the pieces not bought by the museum had been
snapped up immediately by a more appreciative buyer, and proposed
that if the museum hadn't spent so much of its budget flying in
anthropologists and paying for their hotel rooms and expeditions he
could easily have furnished a top-quality collection on his own.

We had booked seats on an Air Martinique flight, but what we
eventually boarded was a jade green, unmarked 727, which turned out
to be a former Braniff jet, leased by the Martiniquan airline, flown by
a Dallas-based "Express One" crew, and staffed by flight attendants
who drawled their safety instructions in Texan English and high school
Spanish. Once in Equatoria, we rented a Yugo and checked out the
"summer camp/orphanage" where the director of the museum had
kindly reserved a room for us. It was far from the center of town,
crawling with vacationing schoolchildren, and furnished with single
cots and a communal shower down the hall. We decided to see whether
we couldn't find a room more in keeping with our role as private
investigators.

Halfway along the road back to Cayenne, we vetoed one small
hotel with Haitian men lounging in front, on suspicion of its being a
whorehouse and possibly unsafe for an unaccompanied laptop. Next
we came to another small roadside place, Chez Ginette, this one
impeccably respectable in feeling. The eager young Creole in charge
installed us in a quiet back room, showed us how to operate the air
conditioner and the phone, and retired. We emptied our suitcase into
the closet and readied ourselves to place a call to Monsieur Lafontaine.

Given his tone when we'd last called from Martinique, we had

been wondering uncomfortably whether our whole trip might end up being for nothing. In that context, the voice at the other end of the line caught Sally by surprise. It was distinctly sugary.

"I'm right in the middle of inventorying my collection," he fretted, "and the place is a mess. But if that doesn't disturb you, it would be my very great pleasure to receive you. Just give me a half-hour; shall we say five o'clock?" He gave directions to the Résidence Les Balisiers, a modern apartment block on the edge of Cayenne, separated by a parking lot from one of the town's largest supermarkets. "Number F-4, but do let me come down to meet you in the parking lot. These days it's no longer considered inelegant to honk."

Before leaving for our rendezvous, we checked in with the museum director to let her know our number in case she received any messages for us or needed to get in touch. Not two minutes later, the phone rang. It was a lawyer in Washington who had recently participated with Rich in a human rights trial concerning Suriname. We had told her a bit about our current project and given her the museum number as a point of contact. Now, hearing that we were about to visit "our" collector, she pleaded with Rich to exercise caution. We were dealing with a potentially dangerous man, she insisted. It gave us pause. We knew she might be right.

Five o'clock. Carrying a plastic bag containing a luxury edition of Stedman's *Narrative* inscribed to "Monsieur Lafontaine" (whose first name we still didn't know), we decided not to honk after all, but poked into what appeared to be Entry F of Les Balisiers. We were beginning to feel like a couple of detectives in a cheap TV serial.

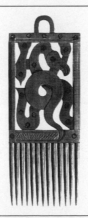

Monsieur Lafontaine met us halfway up the stairs—he must have been watching out his window. After passing through a small dark hallway lined with Brazilian feather art, we were led down a tight spiral staircase into a living room. The furnishings were on the shabby side—a cheap modern couch, a glass-topped coffee table, and a couple of leather butterfly chairs. The significant contents of the room were spread out on the parquet floor and hung from the walls on all sides: headdresses, breastplates, masks, paddles, combs, trays, necklaces, armbands, horns, and some colonial statuettes from Brazil. Brilliant feathers (fire-red, sea-green, sunburst-yellow, snow-white) that looked as though they'd just been plucked from healthy tropical birds. Deer claws, jaguar teeth, bone inlays, tacks of all sizes, grainy woods impregnated with kaolin, fiber ties, wild boar tusks, bone discs, vegetable pods, berries-turned-beads, cowrie shells, and cotton tassels. Was this vast assemblage taking up the whole floor in spite of our visit or because of it?

We recognized our host from the photo we'd seen the year before. Even his dress was familiar—the floral polyester shirt was open nearly to the waist, and an Amerindian necklace, strung with jaguar teeth, held tight to his neck. His trousers fit snugly, and plastic thongs cushioned his feet. The tension we'd sensed over the phone came back as he moved among the artifacts, holding up one after another, and soliciting our admiration. He seemed slightly older than we had expected.

All three of us were sweating profusely. Blaming the oppressive heat, he apologized that the electricity often went off in the building, which turned into an airless crypt without its air conditioning. Sporadic utility service was a feature of tropical living that we knew well

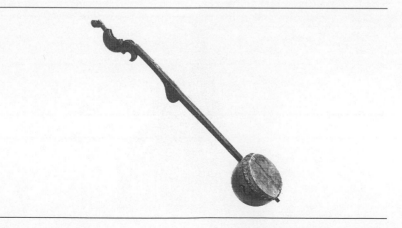

from Martinique, but it was unclear to us why all of the windows remained closed.

He didn't take long to bring up the subject of his poor health. "My doctor gives me only a fifty-fifty chance of returning from my trip to Europe this summer," he announced, almost boastfully. Condemned, he went on, by his heart condition, he was rushing to put his affairs in order, to sell off his collection, and to make the necessary arrangements in France so that his aging mother would be taken care of after he was gone.

Sally pulled the clothbound volume from her bag and held it out to him. He looked uncertain. "Beautiful! May I keep it for a few days? What? For me! Oh, how very, very kind of you!"

Almost immediately he announced that he happened to have a bottle on ice, and rushed off to the kitchen, returning with champagne and three fluted glasses. As we sipped, we played out the roles we'd planned in advance. For us, that meant ample amounts of flattery, visible interest in hearing his stories about objects, an occasional opener about techniques of maintenance and repair.

The objects spread about the room provided props for the discussion that we had been anticipating so eagerly. We found ourselves locked with Lafontaine in a game of mutual exploration, played out through ostensibly casual conversation.

He walked us over to a wall of feathered artifacts and launched into a commentary on the magnificent crowns with multicolored plumes, plush harpy-eagle caps, full-body dance outfits with masks, and yellow-and-red breastplates that had been impregnated with wasps for use in initiation rites. "This cap is Kayapo, and it's very rare . . . I wager you've never come across one of these Wayana breastplates—

they're used to turn boys into men—with all the wasps still in it! . . .
This Yanomami piece is one of my favorites."

Then, reaching up to the bookshelf, he pulled down a well-worn, unbound monograph in Portuguese. "I purchased this years ago in Brazil. It has a number of pieces that are very similar to some I own, but mine are more complete and in better condition." Indeed, in contrast to the museum artifacts illustrated in the book, none of his seemed to be missing a single feather.

He boasted of his success in smuggling rarities out of Brazil. Loosening the waist of his pants, he slipped a feathered necklace around his hips. Rebuckling his belt, he challenged us to notice anything suspicious. Later he took similar pains to reenact for our benefit the wrapping of a feathered panel with a piece of cardboard in such a way that only the unfeathered back surface would be visible to a customs official who unwrapped it for inspection. And several times he mentioned his excellent relations with the FUNAI (Brazil's Indian Protection Agency) and with various generals and colonels. "Thank God for corruption!" he said with a laugh.

The show-and-tell session continued, focusing on particular details and often turning into a proving ground for our ethnographic expertise.

"Do you know what these are?" he asked, holding up a wooden object embellished with white bony spikes.

"They're stingray tails," Rich replied without hesitation. We had already asked some Saramakas about a similar set of enigmatic white spikes on an instrument in the museum's storeroom the previous year. "They're just like the ones on the instruments we saw at the museum. Did you know that stingrays live in the Suriname River and the Pikilio,

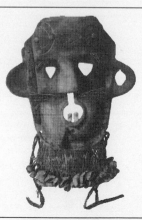

but not in the Saramacca River or the Gaanlio?" Lafontaine didn't appear to mind this ethnographic one-upmanship. On the contrary, he seemed pleased that we'd passed his little test.

Sally then adapted one of the questions she had prepared as an encouragement for talk about restoration, a topic she was convinced could lead to useful revelations. "How do you manage to clean the feathered crowns? They look so incredibly delicate!"

"People always think that feathers are fragile. But in fact if you know how to do it, you can wash them with soap and water and dry them with an electric hairdryer."

"Do you ever use a brush?"

"A brush? Yes, of course."

That was already a small victory in getting him to admit working with the objects. But he was taking it even further. He led us out to his terrace, where a rough table held various spatulas, knives, chemicals, and brushes, and told us that he often had to devote weeks to the restoration of a particular object. "There's so much you have to know about resins, and glues, and honeys."

He began talking about the musical instruments acquired by the museum. They'd been an absolute mess when he got them, he said— little pieces in plastic bags, all needing to be reassembled, reconstructed, and made presentable. He had bought them from a Surinamer born the same year as his own father, 1907. The man, he said, had two sons, one in jail in Caracas and one in Belém, both for murder, and sold off pieces from his family collection to make their daily lives more tolerable. Lafontaine had once been shown a notebook the man had inherited, with the detailed history of each object. Unfortunately,

it had since disappeared. The complete Creole orchestra, assembled
over two centuries, consisted of thirty-two instruments.

The first one he had acquired, some fifteen years earlier, was the violoncello. "Don't you think the bow is remarkable?" he asked. "A Saramaka woodcarver named Awali helped me with the restoration. He was the one who carved the spiral tip. By the way, he mentioned that he knew you." Awali, he continued, had been helping him now and again with restorations for a dozen years. He was the one who had made the wooden pegs used to repair the stool bought by the museum the year before, and he often provided small services of a similar sort. Before Awali, Lafontaine had used an even more skilled Saramaka helper named Confard, a heavy-set man who had since moved away from Cayenne.

Lafontaine stressed the years of hard work he'd devoted to restoring pieces in his collection. It was a real labor of love. On many of the wooden objects, he'd had to insert strong metal wire at fragile points. The beard on the mask had been hanging askew, and had needed to be reattached at each hole. And he'd had to replace the animal hair used for its eyebrows and mustache. "I hope I used the right bristles," he said, almost as a question.

The treatment his collection had suffered when he left it on deposit in the annex was simply scandalous, he told us. Quite a few pieces had been returned to him with missing or broken parts. "Let's admit it outright," he said with some feeling, "it's a *musée nègre!*"

While he was retiring the empty champagne bottle to the kitchen, we went over to a back wall to examine two Saramaka combs with the characteristic dark patina that we'd become familiar with the year before (12, 60). Setting an unopened bottle of J&B and another of

Moselle on the coffee table, he called us back to his bookshelf. "Those combs," he told us, "are very similar to one in a little book I have here."

Judging from what we saw on the shelf, his collection of books on Maroon art was limited to three: Jean Hurault's *Africains de Guyane,* Philip Dark's *Bush Negro Art,* and our own *Afro-American Arts of the Suriname Rain Forest.* He flipped through Dark but without success. "I think these combs may have been among the things I got from some soldiers when I was in Suriname. It would have been 1982. Most of them still had their museum numbers on them, so I tried to get rid of them as fast as I could." We looked but saw no numbers on the combs.

"The director of the museum of Paramaribo, an elderly gentleman, was very kind to me—he speaks a little French and is quite knowledgeable about hanging. The technical details, you know." We realized he was referring to Jimmy Douglas, who indeed had spent most of his professional life, before taking over at the museum, as chief of police. "He told me he had learned the optimum formula—the correct ratio between the man's weight and the length of the cord—from his counterpart in Georgetown many years before. You know, if the cord is too long, it makes quite a mess, and if it's too short the neck doesn't break and the person merely kicks about, slowly suffocating." He smiled thinly. "In any case, I am of the opinion that our guillotine makes a neater job of it!" We nodded politely.

From time to time, he told us how much he depended on our art book to understand pieces in his collection.

"That's how I knew my phallus was genuine. I'd been afraid to let my friends see it, for fear of ridicule. But then I was able to show them," he said, flipping through the pages, "how you wrote that—Ah,

mineral used in U.S. transistors. That's where he'd collected the pieces. He had died a few years earlier.

As we chatted, the three glasses were drained and refilled several times. A lot of the talk turned on money. He told us about one client who had an absolute aversion to haggling over prices. "He just presses a paper bag filled with bills into my hands," Lafontaine said. "Look at what he gave me yesterday." And sure enough, the brown paper bag he showed us was stuffed with 500-franc notes.

Sometimes, he continued, he had money, sometimes not. Often he had to borrow from the bank to buy Brazilian featherwork. And he occasionally went halves with a friend in Europe on a large purchase, splitting the profits once he sold it. That was what he had done with the cassava mill.

"But I'm holding my own these days," he said. "In fact—would you believe it?—I've never been so rich as since I stopped earning a salary! It's such a wonderful system. As long as I keep them convinced that I suffer from nervous depression, I can stay on permanent disability, and I only have two more years to go until retirement. Besides," he added with a smile, "I've been very successful at selling pieces to my psychiatrist."

He seemed to need to stress to us that he had no interest in morality, that he was happy to smuggle, trade in stolen objects, and con his way out of having to work for a living. "To be honest," he insisted, "it's money I'm after."

Occasionally, Lafontaine took it upon himself to draw our attention to curious features of his collection—sometimes referring to objects that he had in his apartment and sometimes to things that we'd seen in the annex the year before, but always ending with some kind

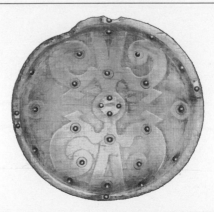

here it is, page 174, I marked the passage—that at Saramaka funerals, youths put on masks and . . ." He paused before tackling the string of English syllables: ". . . dance obscenely with long wooden penises, simulating copulation with drums and making suggestive advances to other participants."

"My God!" said Sally to herself, thinking back to the crude uncarved sticks to which this passage actually referred. Then, out loud: "Have you ever thought about collecting Saramaka women's art like calabashes and textiles? I for one think they're really special. But collectors never seem to give them the time of day." It was a plea she had made before.

"Madame," he replied, "I cannot speak for others, but I myself have never been the least bit tempted by that sort of thing."

We asked if he had ever visited Saramaka territory. "No," he said, "I've never gotten farther than Paramaribo. Quite frankly, I feel no need to see the pieces in their little thatched huts. Besides, I don't speak Dutch or even English. I can get along in Portuguese, though."

As he talked, Lafontaine referred frequently to his small circle of friends and their importance in his life. He could always count on Yves, Claude, and Patrick, no matter what. If he needed money, they never asked questions. Within their little circle there was unconditional trust. He had sold each of them quite a few pieces from his collection, and they often helped him in business matters. He also had many collector friends in Brazil. They all knew one another and liked to trade around objects.

It was another close friend, a Monsieur Breton, who had sold him the mask, the phallus, and the whole set of snake-god objects. He was a mining engineer who prospected along the upper Maroni for a black

of justification for the anomaly. "Isn't it funny that no matter how dark a wood is on the surface, it remains light on the inside?" he remarked, seemingly out of the blue. At another point he noted how odd it was that the handle of his cassava rake was attached on the straight edge, but then suggested that it would make a certain kind of sense if it had been intended for scraping things in a round tray. And he told us a convoluted story about two slave musicians who were brothers, which he'd heard from his Paramaribo source, that explained why two of the mandolins had matching incised designs. He asked whether we'd noticed that some of the complex, multi-media tassels on his Amerindian artifacts were very similar to those on the instruments of the Creole orchestra. When he saw Rich examining the handle of a wooden ladle whose shape matched the neck of the Creole banjo the museum had bought from him, he hastened to identify it as having been made by Brazilian Indians from Matto Grosso. And he complained that it was often difficult to find copper tacks to replace missing studs in the antique carvings, so he was sometimes forced to use other kinds.

As these comments began to accumulate, Rich felt increasingly uneasy. It almost seemed as if Lafontaine was imagining himself in the position of someone appraising his collection and was working to deflect potential criticisms. Worse, so many of the features he singled out for commentary matched those we had discussed with Awali the year before that Rich wondered whether Awali hadn't reported back to him on our conversations. Might Lafontaine be much more aware of the game we were playing than he was letting on?

"Would you agree to be my guests for dinner so we can continue talking?" he asked. We accepted, Lafontaine exchanged his plastic

thongs for a pair of moccasins, and off we drove to the Bistro de la Savane, in the heart of colonial Cayenne.

The décor had been redone recently, but the tone was still set by the tall ceilings, the potted palms, and an overall look of decadence. Our host strode in like a planter on his own estate, with us in tow. A woman sitting behind a table keeping records greeted him by his first name. We were given oversized menus, though he simply set his down unopened, explaining that he knew it by heart. The owner was a plump woman in her fifties with pink-tinted hair. We'd been told by several local residents that she had once been the madam of the city's premier brothel. She tripped over to our table in her little gold heels and gave Lafontaine a warm hug from behind. He ordered a chilled bottle of Chavenet to go with our appetizers of shrimp and main courses of *magret de canard,* and a second was summoned well before the first was empty.

He was becoming expansive, and over the course of the relaxed meal he told us more about his life. There were new stories about Brazil and feathers and smuggling. He confided, with mischievous pleasure, that almost all the "wild jungle animals" pictured on the postcards for sale in Cayenne were in fact photographed in the little zoo he had once run in his back yard. And then there was the anecdote about a woman he'd barely remembered who showed up one day and presented him with a fourteen-year-old boy, announcing that it was his son.

Halfway through the meal he leaned forward and looked Sally in the eyes. "Madame," he said, giving each syllable its full Mediterranean

weight, "I should like you to know that you have very good luck in being married to Monsieur." He indicated Rich with a tilt of his head.

"For if you had, on the other hand, been married to *me* . . ." He paused. "I'm afraid your life would be worth very little. All three of the women who have had the misfortune to live with me have died young, in violent and mysterious ways. The last one dropped dead from a heart attack. They found the body of another one floating face down in the river, with a bullet through the head." Sally wondered whether she saw a smile flicker across his face. "And you know—they never discovered who did it."

After dessert and coffee, we strolled out. His tab was apparently kept without formality. As we exchanged goodbyes, he said he would try to arrange visits to the homes of two friends who had bought parts of his collection, and would be in touch with us at our hotel.

Driving back, we could hardly believe what had happened. It seemed to us that Lafontaine had followed the classic forger's script. As we saw it, he had flirted with the danger of discovery for the ultimate thrill of conning the experts. If he won his wager, we would authenticate his work, and help make him rich and famous. This was also his chance to stick it to the system—the museums, the experts, the anthropologists. As we reviewed the evening, we were struck by how much self-delusion was involved. And by the realization that, if he had possessed a little more restraint, as well as better ethnographic knowledge, he might have won his bet.

The next morning Lafontaine called to invite us for visits to two of his clients' collections. We could pick him up at three-thirty, he proposed,

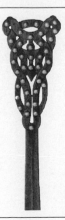

and we should be sure to bring our camera. We wondered whether we weren't getting in over our heads. Could he really have been unaware of our suspicions? What if he was playing with us? Might he be leading us into some kind of trap?

He ushered us quickly down the stairs into the apartment, showed us to the same armchairs as the day before, and asked if we would be so kind as to shut our eyes. That was about the last thing we felt like doing. Edgy, Rich only pretended. Suddenly, a flood of rich sound surrounded us—Elgar's *Enigma Variations*.

"I made this myself," Lafontaine said proudly, as he showed us a series of coffee cans attached to a ganglion of wires—woofers, tweeters, all the noise-makers of 1960s-vintage component systems strung together by heavily soldered wires, and all more or less discreetly camouflaged in his bookcases.

"I can't resist an opportunity to tinker," he admitted, "and I'm rather a perfectionist when it comes to music, especially opera." He began to speak with excitement of Puccini, of Callas, and of the "divine" Anna Moffo. "By the way," he queried almost as an afterthought, "are you opera-lovers?" Rich held up our end of the conversation by recounting some of the stories of opera greats—from Caruso to Tebaldi—he had heard from his grandfather, a lifelong member of the chorus at the Metropolitan Opera in New York.

As the emotional "Nimrod" variation swelled to its climax, Lafontaine turned to us, waiting. Once the massed strings had faded away, he finally spoke again. "Did you know," he asked, "that the marvelous setting for the ballet by Sir Frédéric Ashton, in the garden of Sir Édouard's home, went against Elgar's own concept? He had

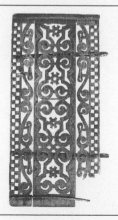

wanted it danced in a banquet hall, with a veiled dancer as the Enigma!"

Lafontaine was even more effusive than he'd been the previous evening and, after we'd each had a glass of wine, said he was eager for us to meet Madame Charrière, to whom he had sold "a very special tray." A brief drive and then up the stairs of a modern apartment block built in vaguely Andalusian style, through an ornate grillwork security gate, and into a supremely bourgeois little home—tea service laid out on a low table, contemporary art from the Pacific on the white walls, Madame Charrière herself in a lacy bra lightly covered by a pink chiffon blouse, with tired-looking eyes and unfreshened lipstick.

Cordial greetings, a certain formality, an air of expectancy about how we would react to the *pièce de résistance*. There it was in the place of honor over the large settee, a handsomely carved concave disc set into rectangular openwork wings—"a tray for festive occasions," as Lafontaine informed us.

There it was. Its monkey-tail spirals were executed as lightly squashed, rather than perfectly circular, free forms, and it was held out from the wall by the downward curve of the two ends (118). We stared at it in wonderment. It was indeed a very special carving.

"I bought it from the same man in Paramaribo who's been selling me the instruments," offered Lafontaine, visibly pleased at our wide-eyed expressions. He specified that he had waxed it at Madame Charrière's request, which accounted for its shiny patina. Sally noticed a broken edge on one side of the tray itself. Had it been placed there to enhance verisimilitude? Hanging just underneath the tray was an oversized food stirrer (37), whose openwork handle neatly matched the carving on the tray's wings.

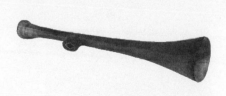

"I've explained to Madame Charrière," Lafontaine said, warming to the role of expert, "that every ceremonial tray has its accompanying spoon." We smiled politely, wondering where he could have picked up this bit of ersatz ethnographica. "I once asked Awali whether he could carve a tray like this," he went on, "and he said no, that those techniques had long since been lost in Saramaka."

In an unctuous voice, he then made a formal request that we be allowed to photograph the masterpiece, which it was Madame Charrière's great pleasure to grant. We improvised some lighting, and off she went to take her cake out of the oven. While serving homemade guava jelly, cake, and tea, she inquired whether we'd had a chance to see Catherine Deneuve in *Indochine,* which was playing at the local theater. She and her husband had found it absolutely exquisite. Lafontaine remarked that he had not been able to enjoy it fully because the print sent from France was too narrow for the new Panavision screen at the Rex. "When it comes to technical detail, I'm a real perfectionist," he confessed.

Madame Charrière then treated us to a tour of other *objets d'art* in her living room. Besides the pieces she and her husband had acquired during their years in New Caledonia, there were several items she had bought from Monsieur Lafontaine: a Lebanese coffee grinder, two finely worked silver stirrups from Brazil, and a gaucho dagger for spearing churrasco. The bone disc embellishing the handle of this last piece struck us as distinctly familiar-looking.

Back in the car, the three of us headed down a narrow road toward the sea and the home of Monsieur Peronnette, who we found pointing

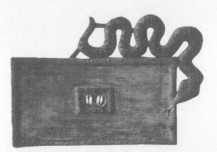

a hose at a hibiscus bush. He pulled on a shirt and showed us into his living room without ceremony, leaving the talking to Lafontaine. As in his shop the previous year, he came across as a no-nonsense businessman.

The place was filled with canoes, paddles, stools, drums, trays, combs, a stuffed armadillo, some old engravings, and even the massive cassava mill that Lafontaine had been prevented from exporting the year before. As we scanned the walls, it was as if veils had suddenly been lifted from our eyes. Despite the presence of a few plausible-looking artifacts (a small canoe, some painted paddles, and a few tourist carvings), an aura of inauthenticity seemed to hang heavy in the air.

Lafontaine hastened to point out that, as with Madame Charrière's set, each of the two wooden spoons we saw on the wall "went with" a particular winged tray. He was distressed to see that they had been hung in incorrect combinations (93, 79, 115). He seemed especially eager to get our compliments on the trays, and we had no trouble telling him we had never seen anything quite like them before.

"What an amazing hunk of wood you would have needed to make that!" he marveled about the larger of the trays. "Awali tells me he can't find timber like that any more, even if he goes all the way to Suriname!"

As we walked around the room, we saw an apparently ancient, and vaguely familiar-looking, laundry beater on a table. On picking it up, Rich was startled to realize that it had been made of light South American cedar rather than the heavy wood normally used for these clubs. On the floor was an *apinti* drum, whitened with kaolin and embellished with bas-relief rattlesnakes, more realistically rendered than the designs we'd seen on other Maroon drums (46).

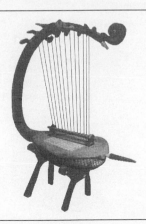

In reply to our questions about provenance, Lafontaine repeatedly cited his Paramaribo source. Fishing for information, as he had done several times before, he asked us whether drums weren't sometimes "covered absolutely all over with kaolin." He cued us to provide compliments with growing frequency, asking, for almost each object we examined, whether we didn't find it beautiful. When Sally exclaimed cooperatively that the entire collection was *très belle,* he muttered excitedly, "And well it should be! I've devoted twenty-three years of my life to making it happen."

Passing on to Peronnette's cluttered study, we saw an authentic-looking *agida* (snake-god drum) but little else that didn't arouse our suspicions. On one wall were several Amerindian accessories in fiber and basketry, lavishly hung with bone discs, berries, claws, and feathers, each of which Lafontaine took great pleasure in identifying. There was also a woman's *cache-sexe* dripping with vegetable pods much like one we'd seen in his apartment, and a composite dance anklet suggesting to us a left/right pair that had been sewn together with string. There was a heavily waxed plank-top stool (20) whose sinuous open-work designs troubled both of us, though we couldn't figure out why. On the wall we saw an ornately carved paddle (13), two more winged trays (87), and two round trays, one of which was shiny black and featured a stylized man with sex exposed (90). "Note the decorative tacks on the testicles," commented Lafontaine, like a docent at the Louvre.

He told us he had devoted entire weeks of his life to restoring one of the winged trays. For other objects, he said that he'd acquired them in pristine condition. We sensed a strong ambivalence about his claiming or denying artistic credit.

As we examined the pieces in the study, Lafontaine discreetly called his friend into the adjacent bedroom and held a whispered conversation with him. When they returned, Peronnette told us it was all right to take photos, as long as we understood that he didn't want publicity about his collection. "All that would do is attract burglars," he said, though we surmised that French luxury-taxes might also be motivating his wish for privacy.

Peronnette expressed interest in buying a copy of our art book, and we said we'd be happy to drop one off as a gift the next day. But he vigorously insisted on paying, remarking, "Credit makes bad friendships, and who knows, I may need a favor from you some day."

After we said goodbye and the three of us walked to the car, Lafontaine congratulated himself on getting us permission to take pictures: "I could tell that you were hesitant to ask," he said. During the ride back, he twice told us with some emotion that he hoped we didn't think he had wasted our time by the afternoon's visits. We assured him that we'd found them fascinating.

He mentioned that there was one other collection he wanted us to see, which included objects the museum had declined to buy the year before. Unfortunately, the owner was in Europe at the moment and his son, who'd never been very accommodating, had turned down his request to bring us by. "Perhaps on your next visit," Lafontaine said, "though it's far from certain. Patrick cherishes his privacy. He's a well-known figure here, though in fact there are only four or five people in Cayenne who know him at all well. I must say he considers me one of his closest friends."

After dropping off Lafontaine, we headed for the one-hour photo shop in the center of town. While the pictures were being developed,

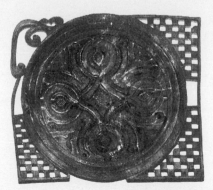

we sat in a café and tried to take stock. In the twenty-four hours since we'd met Lafontaine, the big question we had been living with for over a year had dissolved—and been replaced by a hundred smaller ones. We no longer had any reasonable doubt that the great bulk of Lafontaine's collection had been fabricated to deceive. What remained now was to uncover by whom and how and why. The goal of the game had been completely redefined.

The photos came out pretty well. After dinner we spent hours poring over the full set—the ones from that day as well as those we had taken the year before at the museum annex. Since having talked with Lafontaine and viewed his pieces in his apartment, at Madame Charrière's, and at Monsieur Peronnette's, our vision had been irreversibly altered.

There was the pervasive dark patina. The waxed shininess of many objects. The omnipresence of corroded tacks. The bone discs and inlays. The rounded, or sometimes ridged, surfaces of bas-relief bands. The inattention to perfect symmetry and geometric regularity. And there was the striking frequency of erect arched forms: the sawed-off canoe prows, the phallus, the plumed headdresses, the harp.

The whole collection was punctuated by glues, resins, wooden pegs, thorns, Phillips screws, pieces of wire, and even nails fashioned from bone. Now we could not but see an aesthetic of the repaired antique, a particular vision of the fussed-over and pieced-together *objet d'art,* replacing Maroon artistic ideals that champion a carver's ability to turn a single block of wood into a beautiful object. This aesthetic, we now realized, even affected much of the openwork; the tendency to connect design elements with separate bits of wood effec-

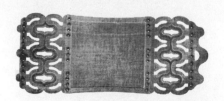

tively spaced out compositions which, had they been made in a Maroon village, would have been more tightly executed.

For more than a year we had been pushing ourselves to imagine independent life histories, however unlikely, for the individual objects in the collection. But now Lafontaine was almost forcing us to position him at center stage in the drama. He had pulled away the straws we'd been clutching at in our attempt to create a legitimate past for his pieces. From here on out, our efforts would have to focus on the reconstruction of life histories that somehow acknowledged his agency.

We had to talk with Awali. The things we'd learned in the last two days gave new meaning to the proverbs he had cited in the annex. And we now knew he had lied when he denied knowing Lafontaine. In the car, we tried to figure out how we could smooth over this awkwardness.

"I don't think Awali will mind talking as long as he doesn't feel we're accusing him of something," Sally said.

"I don't see that we have a choice," Rich replied. "Let's just act like there's no problem and talk about Lafontaine as if we'd never showed Awali the photo of him." Indeed, it looked like the only way to go.

When we pulled in at Awali's sign the roadside shed was empty. Walking up the hill to the compound, we found two of his sons wielding a chain saw, cutting heavy slabs of wood that would be hewn into interlocking halves to make the folding stools that so many tourists pictured as embellishments to their dens and living rooms.

There were little kids everywhere. Back from the work area, Selina was in front of her daughter's house, cradling a week-old baby in her

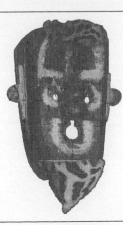

arms. In the customary gesture, she handed her human package to Sally when we came over to say hello. The head was covered with an embroidered patchwork cap and the tiny ears had been pierced and threaded with bits of cotton string. A woman to carry on Selina's lineage. Rich expressed his pleasure at the new "wife" he'd found, and Selina beamed.

Hearing our voices, Awali emerged from the next house, and we exchanged greetings, straining to speak over the grinding of the chain saw. He invited us inside, handed us stools, and closed the door partway, leaving space for some light to reach the windowless interior. Selina installed herself on the doorstep, ready to take back the child after an appropriate interval.

We began by catching up on events of the past year. Awali had been back to Suriname twice. We'd been in Washington with a group of Saramakas at the Festival of American Folklife, and had stories to tell about that. The recently installed Chief of the Saramakas had been in Cayenne on an official visit. And Rich had flown to Costa Rica to testify in a human rights trial that pitted the military government of Suriname against the families of seven young Saramakas who'd been tortured and killed by soldiers. Sally pulled the gifts we'd brought out of her shoulder bag, and Awali sent one of the children to the Chinese grocery across the road to buy cold soft drinks and beer.

"Our plane came in Saturday," Rich answered when that question was asked. "We would have stopped by sooner, but we've been pretty busy. We've even spent some time with a friend of yours." He paused. "The man they call Lafontaine."

"Lafontaine?" Awali's face revealed neither surprise nor recognition. He left it up to Rich to carry the conversation ahead.

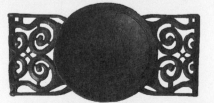

"Yes. He invited us to see his collection. When we got to his place he served us *shampani*, and then he took us to dinner at the Bistro de la Savane. He talked about some of the work you've done for him. Also Confard. He showed us his workroom. We enjoyed getting to know him, and he seemed really pleased too."

"He showed you where he works?" Awali repeated, still without committing himself to an identifiable reaction.

"Right. He seemed to want to share everything with us. We got along really well."

Selina pushed gently on the door, slipped inside, and took a seat on a block of wood next to her husband. She had the fingers of one hand over her mouth, but the chain saw had been turned off and we could hear her whisper. "Are they talking about Tambou?" Awali nodded almost imperceptibly.

"Tambou?" Sally echoed, unsure. Selina fixed her eyes on Awali's face, ready with a look of caution if he sought it, but not interfering. He stared down at his feet. Then he turned to Rich and pressed his lips together. After another moment he smiled, with only the slightest hint of sheepishness. "That's what we call him around here," he explained. "But you shouldn't ever use it to his face. He doesn't know about it. When he's here I always call him Émile."

"Why Tambou?" Rich began to entertain the idea that our approach was going to work.

"Because that's what Frenchpeople call drums—*tambou*. It's the first thing he ever bought from me, and he ended up buying lots of them, so we just started calling him Tambou." Unspoken thoughts were beginning to hold the four of us in a web of confidence.

The child came back from the store and the conversation returned

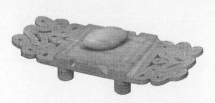

to small talk as Awali opened the drinks. Selina reminded us that she'd been looking for new cross-stitch pattern books, but Sally said she hadn't been able to find any. Awali asked if we could help him extract the second part of a payment that was due him from the museum, and we agreed to try. Rich deliberately repeated Confard's name.

"Confard?" Awali seemed genuinely puzzled.

"He's a carver. Lafontaine said he used to work for him."

"Oh, you must mean Konfa. He's a cousin of mine. Lafontaine dropped him because he wasn't following instructions. When someone gives me a job to do, I make sure to do it exactly the way they ask."

"Is that the Konfa who used to dance *sêkêti?*" We'd heard of a famous dancer of that name back in the sixties. Awali nodded.

We had to act casual, but given what we'd been learning it wasn't easy. We said our goodbyes and made plans to return the next day for another visit.

On the way back to Chez Ginette we bought a bottle of Scotch. It seemed like a moment to celebrate, or at least a good time to take a breather. Awali had told us he had sold many things to Lafontaine. He'd said that Lafontaine provided precise instructions. And that "Confard" had worked for him on that basis too.

For the umpteenth time, we spread out the photos on the bed. What was it that made the objects look so hauntingly familiar, so beautiful, and yet so strange?

Early the next morning, Rich awoke with a start. "I've got it!" he grinned. He was very excited. Sally looked at him sleepily. "I've

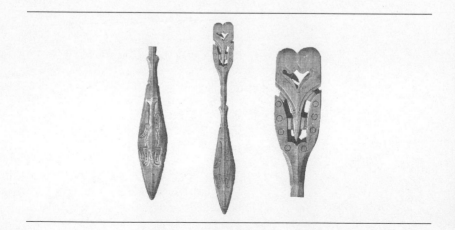

just had a dream about squiggles," he said. "Peronnette's winged tray. I think I know what it is!"

He jumped out of bed and stood naked at the dresser, flipping through the pages of our 1980 book. When he got to the end of the woodcarving chapter, he stopped turning and stared at a duotone photo of a plank-top stool with beautiful openwork carving. There it was. The image from his dream (3).

We pulled out our photos again, and shuffled through the pile to find Peronnette's tray (87). Setting book and photo side by side, we saw that the tray was a cunning manipulation. The undulating bands in the stool's design had been pulled out on the right and left to form the tray's "wings," leaving the stool's central circular band to be executed as a solid concave shell, the "functional" portion of the tray. Other changes had also been made in the design. The flat surfaces of the bas-relief bands had become rounded, almost ridged. Dowel-like pieces had been added at the two ends to frame the whole. And an incised anchor motif had been etched into the concave space of the tray.

Now that we were catching on, it didn't take us long to identify that incision as one we had seen in Hurault's book on Aluku art, captioned there as "an abstract masculine symbol."

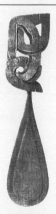

Elated, we worked through our woodcarving chapter more systematically, searching for models. Three more times we had that rush of recognition, as we discovered even more obvious matches: the book's Figures 135, 171d (108), and 178 (71) were clearly the originals for Peronnette's laundry beater, one of his paddles (13), and his openwork stool (40). Yet even in these pieces, subtle changes had been introduced. The carving of the paddle's handle had been elongated, and the laundry beater's tacks had been deleted.

The stool's transformation was particularly complex. The tacks that covered the entire surface of the original had given way in the copy to ten lone studs. The sinuous openwork bands had been narrowed. The wood had become dark, and shiny with wax. Two of its four base panels had been copied, but in a squatter version. Most interesting to us, the irregular over-and-under alternation of the openwork bands, so typical of early-twentieth-century carving, had been "corrected" in Peronnette's stool, according to the principles followed by later generations of artists. Would Lafontaine have dared to make that change? It seemed more likely to us that a modern Saramaka carver, too proud of his skills to commit the "mistakes" of a cruder stage of Saramaka artistic development, had executed this logical "improvement."

Before returning to Awali's, we decided to see if we could track down Konfa. A Saramaka construction worker provided directions that took us about half an hour out a small country road to the west. There, behind the crudely lettered sign advertising his trade, we found him in his open shed, pocket knife in hand, bent over a woodcarving. About

ten years Awali's senior, we guessed, he was wearing metal-rimmed spectacles. His graying hair was braided.

We introduced ourselves and told him that some of the dances he'd invented in the sixties, including one that mimicked a Coca-Cola bottling machine in Paramaribo, had provided examples of Saramaka creativity for the art book we had written. We'd never met him, but his reputation as a dancer had been unparalleled. He seemed pleased at this reminder of his days as a celebrity, but told us that the envy people had of his skills had cost him dearly. "I've had jealousy for dancing. I've had jealousy for carving. I've had jealousy for hunting," he said with ill-disguised bitterness. In fact, he told us later, that was what had made him break with Awali.

Years earlier, he said, Awali had tricked him out of a lucrative commission for panels to decorate a government building in Paramaribo. And there were others who resented his gifts in the arts and success as a hunter. Saddened, he had finally decided to retire to a quiet spot in the country with his wife and children, forgoing both fame and the problems it brought with it. From the gentle, deliberate way he spoke, we wondered whether he hadn't also gone through a religious conversion, but decided it would be indiscreet to broach the subject.

"We hear you used to work for a Frenchman called Lafontaine," we prompted. He raised his eyebrows skeptically, but answered the question he understood us to be asking. He'd worked for him over a couple of years in the early eighties, making scores of objects—paddles in both Saramaka and Aluku styles, trays, combs, drums, canoes, laundry beaters, and more. Picking up a copy of *Africains de Guyane* that was lying next to him on the bench, he turned the pages to show

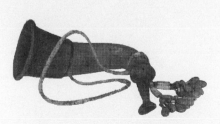

us more than a dozen objects he'd copied, some of them many times. He displayed no warmth toward his former client.

"He used to drive up in a little red car with no roof. Sometimes with an ocelot in the other seat." He stopped and shook his head, remembering. "He and his friends do that thing that Frenchmen do. Y'know, they play girlfriends."

"Lafontaine," he went on without being asked, "rubs a kind of powder into the carvings he commissions to make them look old. That's so he can get a higher price. There's no reason for it except to cheat his clients."

We expressed shock at what he was saying, but didn't interrupt his monologue.

"It's just like when Saramakas make up symbolic meanings for their designs because the tourists like it. A lot of carvers are willing to go along with those kinds of things for money, but not me."

His moral stance had not prevented him, however, from being very curious about the powder that Lafontaine used to produce the patina on wooden objects. In fact the powder had fascinated him, and he'd done his best to persuade Lafontaine to tell him what it was, but always without success.

While we were talking, Konfa's wife came out to the shed, and both of them bent over the photos we'd brought of pieces from Lafontaine's collection. Like Awali, Konfa made clear that he had never been allowed to place decorative tacks on the objects he made. The bone inlays on some of the pieces horrified both of them. They'd never seen them before. "It's one thing to use tacks or wood inlays," said his wife, "but with bones how do you know they're not human?" She shuddered.

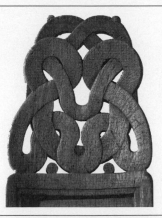

As Konfa talked, it became clear that Lafontaine's visits had served, over time, to mold a style of woodcarving that responded to his particular aesthetic tastes. In itself that was not unusual, since Saramaka carvers often work with the object's eventual owner in mind. A man carving a paddle, for example, may daydream at the same time about the woman he's planning to give it to. But Lafontaine was pushing that tendency a step further. The features he was requesting on his commissions were beginning to define an art style that didn't fit neatly into either of the two standard modes that Saramaka carvers worked in—art for use by Saramakas and art for sale to tourists. And just as Konfa had mastered first the woodcarving style of his home village on the Suriname River and later the aesthetically distinctive style that sold well to tourists, he had taken Lafontaine's particular tastes as a professional challenge.

We gave Konfa the Saramaka music cassette and art book we'd brought as presents, his wife reciprocated with some okra from their garden, and we took our leave. We had a meeting scheduled with the museum director in less than an hour.

The director greeted us and asked politely how our visit was going. We passed along Awali's concern about the money still due him, and she replied that it would be taken care of in the coming weeks. The budgetary crisis in Equatoria had slowed down the whole apparatus of government.

We hadn't intended to report more than the bare outlines of our unfolding saga with Lafontaine at this stage, but we found ourselves spilling out the better part of what we'd learned—carefully shielding,

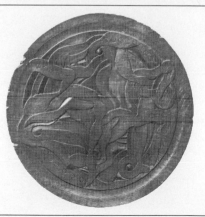

however, the identity of the Saramakas involved. Just as Lafontaine had probably told us much more than he'd intended out of pride in work well done, we found ourselves telling the director more about our own investigation than we had planned. We told her about the resemblances between his pieces and carvings in our book, his use of powder to simulate age, and his own artistic role in adding bone inlays. She clucked her tongue and shook her head.

"I've always suspected he was a pervert," she said. "A taste for shoving bones into pieces of wood is sick. He must be involved in S&M."

At that point, the director's intercom buzzed, and she answered. With a twinkle in her eye, she asked us whether we'd like to eavesdrop. "It's him," she whispered.

The unctuous voice on the speaker-phone took Sally back to her first conversation with Lafontaine. He was calling as a courtesy, he said, to let the director know that he was leaving in a few days for a trip to Europe. He had clients who were eager for an opportunity to purchase the pieces that she had declined to buy the year before.

"By the way," he went on, "did you know that the Prices are in Equatoria? They paid me a visit and viewed my collection."

"Is that so?" the director replied.

"Yes," he said. "Not only that. Before they left my apartment they pronounced the word *merveille!*"

The director raised her eyebrows, but made no audible response. Once Lafontaine had brought the conversation to a close, she wished him bon voyage and touched the off button on her phone.

We described how Lafontaine had taken us to see pieces he'd sold to Madame Charrière and Monsieur Peronnette. And how he had said he wanted to take us to a third collector, someone named Patrick,

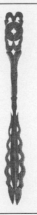

who'd bought many of the pieces the museum had had on deposit the
year before, but who was apparently away on vacation.

"Patrick? That's probably Patrick Benoit. He's one of the richest
men in Cayenne." She smiled. "Let's find out if he's really on vacation."

Buzzing her secretary on the intercom, she got Benoit's number
and dialed. "Hello, may I please speak with Monsieur Benoit?"

She was told that he wasn't home.

"I really need to talk to him. When could I catch him?"

The voice on the other end explained that he was vacationing in
France and wouldn't be back until the twelfth. She thanked him and
hung up.

"Information confirmed," she reported.

"But what would you have done if he'd answered the phone
himself?" Sally was taken aback by her audacity.

"Oh, I'd have thought of something."

Much of the meeting was devoted to the director's stories of her
ongoing battles with Lafontaine to keep him from exporting objects
that formed part of the "cultural patrimony" of Equatoria. We, mean-
while, were giving her information strongly suggesting that many of
the objects she'd been protecting from export had in fact been born
yesterday. She seemed reluctant to draw the obvious conclusions, no
doubt still holding out hope that the first set of instruments, the ones
she had bought for the museum, might somehow turn out to be
authentic.

That afternoon we returned to Awali's compound, taking our photos
as prompts for, we hoped, more details of his collaboration with

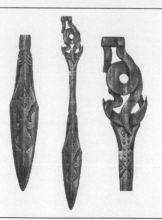

Lafontaine. The story didn't come out all at once. Even after committing himself to telling it, Awali moved only gradually into the details of his role. Nothing was rushed. There was no hint of contradiction in his shift. Grateful, we didn't press, but gave him every opportunity to elaborate pieces of the puzzle at the moments that felt comfortable to him.

Lafontaine had been an off-and-on client over the past twelve years and was a familiar figure to Selina and the others in the compound. Through him, Awali had also met Peronnette, who had once asked him to add some decoration to the tall, uncarved snake-god drum Lafontaine had sold him. Sometimes "Tambou" would bring a piece of paper with a drawing in pencil, asking Awali to execute it in wood. Other times it was a full-size paper pattern, designed to be folded around a three-dimensional volume of wood. As soon as Awali's work was completed, Lafontaine always made a point of tearing up the paper on the spot.

When he used book illustrations to show Awali what he wanted, it was more often a part of something than a whole object. He'd take one motif from a tray and another from a paddle, for example, and explain how he wanted them positioned on a stool. And there were certain aesthetic features that he encouraged Awali to develop, such as relief carving with rounded rather than flat surfaces. He had drawn the contours he was after from various angles and brought back flat-surfaced carvings several times before Awali was finally able to satisfy him.

Although most of their business was conducted in the compound behind his woodcarving shed, Awali had also been to the Balisiers apartment and once had even met a woman who was living with

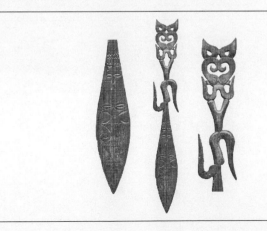

Tambou. He was instructed never to mention his work to her. It wasn't any of her business, Tambou said, and women had loose mouths.

Often, Awali told us, Tambou would have him carve an object without decorating it. Then, at some later date, he'd bring it back with lines marked on it in pencil, asking to have the design carved in relief. Or he'd bring in a small stick or block of wood, giving precise instructions about each of its dimensions, but without telling Awali what it was. The production of some objects would take several visits at the compound, with requests to shave off a bit on one side, to increase the depth of openwork bands, or to alter a particular curve.

One thing Awali was never allowed to do was insert the decorative tacks. Unlike the tacks he always used in his own carvings, which came from Holland, Tambou's were made in France. They were "white" instead of "red," so they rusted with time. To us, Awali expressed personal disapproval of this choice, but he also made clear that the tacks weren't part of his responsibility. And he certainly never had anything to do with the bones, he was quick to add.

A couple of years before, Tambou had brought him a copy of *Africains de Guyane,* and some of the things he commissioned were modeled directly on its illustrations. The line drawings worked especially well, Awali noted, because they gave clear detail. He went back to a wooden crate inside the house and brought out a tired-looking copy of the book, just as Selina appeared bearing a tray with several covered bowls, a teapot, plates, and spoons, and set it on the floor. As we turned the book's pages, Awali's eye was caught by a line drawing of a detail of a food stirrer. "Tambou asked me to carve that as a canoe paddle," he volunteered. "A storekeeper friend of his has it now. I could take you to see it, if you like. But first let's eat."

Selina beckoned Sally to another part of the porch, where she had set out the cooking pots and a sparkling saucepan with cool drinking water, and handed her a plate and a spoon. Even in urban Cayenne, the Saramaka custom of separating men and women for meals was respected. Looking toward a younger woman standing nearby, Selina called out, "Come eat with us, wife-of-my-brother-in-law." It was an odd form of address. "I'm coming, wife-of-my-brother-in-law," echoed the other woman. Sally, who knew that Selina liked to play with words, realized that the woman must be married to one of Awali's brothers.

After a delicious meal of rice topped with fish cooked in palm oil, we set off in the car with Awali. There were no street names in his mental map, but he directed us through Cayenne with the confidence of a hunter in the rain forest. Our destination, we saw as he showed us where to park, was L'Alouette.

Monsieur Revel welcomed us effusively. "It's terrible," he said, when Awali greeted him with "Bonjou'." "I should be talking to you in Saramaccan, but my progress has been so slow. I still haven't found a textbook, and when I try to get Tapi to teach me—I've told him that even just two words a day would keep me going, and I'd be so happy—he always says he's too busy. I guess I have only myself to blame for that! Now how does it go? *Waikee-oo?* Did I say it right? Well anyway, do come in. I'm so glad to see you."

We explained that we had come to see the paddles he'd bought from Monsieur Lafontaine, and he beamed as he turned his gaze to the wall where they held pride of place (24, 50, 102). Awali was already staring at them. He saw that there were not three pieces, but

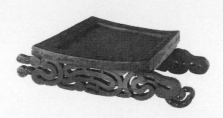

Next to each of the dark, tack-studded paddles was an exact copy, executed in a brilliant blond hardwood, polished and without tacks. Revel noticed Awali's interest.

"Aren't they beautiful?" he gushed. "Of course the new ones can't compare with the originals, but I'd never part with those in any case. So I asked Tapi to make copies for me to sell. I couldn't decide whether to use tacks, like on the originals. In the end Tapi told me he thought it was okay to leave them off if I liked that better. I'm always careful to make sure my customers know they're buying reproductions, not authentic antiques. They go for 2,500 francs. For quality like that, people consider them a bargain." His face settled into a smile of satisfaction.

Awali had been looking at the wall while Revel babbled. "I made the three dark ones," he said to us quietly in Saramaccan.

"Does he like them?" asked Revel eagerly. "What does he think of them? Does he know what village they're from? What did he say?"

"He says they're really magnificent," we translated. Then we asked Awali if he had understood who had made the copies.

"Tapi's a nephew in my lineage," he said. "It makes sense that they're well carved."

We asked Revel if we could photograph the paddles, and he agreed enthusiastically. Awali held each pair, posing in the sunlight outside the boutique.

On the way back, Awali told us that Tambou had asked him to copy two of the paddles directly from illustrations in Hurault's book, rather than from paper patterns. When we arrived at the compound, he showed us the models. Hurault's Figure 30 was drawn after a food-stirrer's blade (78), though making it look like an openwork handle,

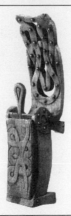

and was captioned as "a mocking, derisive reduction of the female body to the genitals and lower limbs, which is not lacking in charm." His Figure 72 (drawn after 120), was described in the Frenchman's book as "an abstract representation of the male and female sexual organs detached from the bodies."

If Awali had been able to read, he might have chuckled at the book's interpretations. Lafontaine, we speculated, would have digested them with a different kind of interest. As for the third paddle, which was a real beauty, Awali told us it was based on a simple sketch provided by Tambou—three circles topped by a crescent. The rest he had created on his own.

Every detail he volunteered about his work for Lafontaine suggested new questions, but we feared that overeagerness on our part might dam the flow of information. The conversation turned to the economic situation in Suriname for a while and then the construction of a table Awali had agreed to carve for us. After some more small talk, we took our leave and headed back to the city.

Grateful once again that the French civilizing mission had resulted

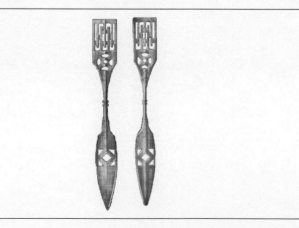

in one-hour photo developing on the Place des Palmistes, we got our
film through the process quickly and fanned the snapshots out on the
dashboard of the car. There was the Saramaka master carver from the
Suriname rain forest, holding the carved-for-hire paddle he had copied
on command from a sketch in an art book written by a French
geographer, which had then been studded with tacks and antiqued by
a high school teacher from the Côte d'Azur and sold for a pretty sum
to a classy souvenir store. And in his other hand he gripped a "quality
reproduction" being grabbed up eagerly by tourists for four times the
amount he'd received to make the "original."

Ironic. But then, what could be more complex than the relation-
ship between originals and copies? Especially when the issue is spiced
with money.

Consider the case of J. S. G. Boggs, an American who specializes
in paintings and drawings that resemble paper money. Although his
"copies" are drawn on one side only and include phrases like "E=mc2,"
"LSD," and "Federal Reserve Not," the Secret Service claims he's a
counterfeiter. Boggs protests that "they don't understand the difference
between art and crime." And he has a point. Rather than selling his
artwork through galleries, Boggs enacts a kind of performance in
which he "spends" it on goods or services, explaining to each mer-
chant that he is an artist and wants to conduct an "exchange." For
each such "sale," he requires a receipt and change in real money, both
of which he then sells to collectors, who use the receipts to track down
the owners of his bills, which they then offer to buy. "Each transaction
is complete when all elements of the deal—the Boggs bill, the change
and the receipt—are framed on a collector's wall," a newspaper article
explains. In a 1987 counterfeit trial in England, Boggs was found not

guilty and paid his lawyers in drawings. Boggs estimates that during the past eight years he has exchanged these bills for "more than $250,000 in goods and services, including meals and hotel rooms, airplane tickets, clothes and a motorcycle."

That evening, at Chez Ginette, we thought back over our jam-packed day: the realization that Lafontaine had commissioned copies of pieces from our book, the talk with Konfa, the meeting with the director, Awali's multiple revelations about his work for Lafontaine, and the discovery of copies of copies of copies of paddles that tourists were buying from Revel. Working further into our bottle of Scotch, we talked about the scale of Lafontaine's operation.

Awali had shown us a large number of book illustrations that Lafontaine had asked him to copy, but we had come across only a limited number of the objects he'd produced. Likewise, we had many photos of objects that Awali, sometimes with the help of Selina and his co-workers, had identified as ones he'd made after sketches provided by Lafontaine but that, despite our searches through books, we couldn't trace to a published source. Considering the volume of objects Awali said he had carved for Lafontaine—many dozens of combs, paddles, food stirrers, drums, and trays—and adding in the considerable numbers that Konfa described, there were surely several hundred fakes we'd never seen out there in the world. How many, we wondered, were in major museums? How many in private homes in Amsterdam, Berlin, and Paris?

The whole notion of forgery, and the question of our own ethical responsibilities, made quite a tangle of issues. We remembered Ernst

Gombrich's caveat that a work of art cannot, in itself, be fake—that statements can be true or false, but pictures can't. Art can't be true or false, Gombrich argued, any more than statements can be blue or green. Which means that deception takes place in attributions, labels, and stories about the objects, not in the objects themselves. It follows that fakes aren't created by artists, but rather by the experts who authorize attributions. As Orson Welles once commented, "The experts are God's own gift to the faker."

How could we help assure that false attributions were not permanently attached to the objects that Lafontaine had fed into the market? By putting their real life history on record—which meant not only writing about them but informing the local museum director and sending letters to museums around the world that might be on the market for this type of art. We'd have to hope that in twenty or thirty years, when some of the objects in private collections were passed on to museums, there would be at least some curators who remembered this case.

In the meantime, who in fact was being ripped off? Awali and Konfa? The Saramaka people? Lafontaine's friends and other private clients? The new museum and its visitors? The French state? The "cultural patrimony" of Equatoria? The world of knowledge? Who was implicated and in what ways? What were the stakes? What were the consequences? And for whom?

As anthropologists, we tended to think about forgery as a cultural construct, with particular cultures, at particular historical moments, holding distinctive notions of what separates use from abuse in artistic borrowing. But that raises many questions. If there is a continuum from "legitimate imitation" to "exploitative forgery," what are the

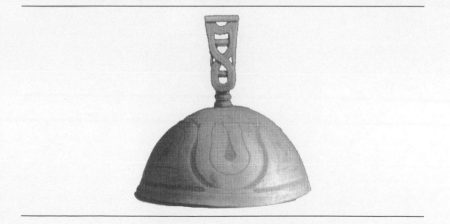

variables—in our world, at the present time—that situate particular cases in a moral universe? When does the scavenging and recycling implicit in all art begin to violate people's rights? And how should cultural difference and relative power be taken into account within this system?

We had been involved during the previous year in some related debates which helped us think about these issues. As members of "The Working Group for a New American Sensibility," sponsored by National Public Radio and the Mexican Museum of San Francisco, we had contributed a paper exploring issues of cultural property, and had benefited from the group's discussion of it. The whole issue of cultural property had been laid on the table, including the question of whether artistic ideas and forms were (sometimes? always?) individual or group possessions.

Mari Matsuda, an Asian-American legal scholar and self-styled "critical race theorist," had spoken about the struggle to relativize the powerful and specifically Anglo-American definition of property used in U.S. law. Suzan Harjo, a Cheyenne activist, had called attention to the Indian Arts and Crafts Protection Act, passed by Congress in 1990, designed in part to monitor artistic "borrowings" across cultures in contexts of differential power. There, she said, the central issue was "pseudo-Indians, who pretend to be us, making things that look like they are made by us, and getting quite a lot of money (or maybe not), but at any rate, who are marketing us in the marketplace and accruing no benefit to the people who are the real-deal Indians."

Bernice Johnson Reagon, a Smithsonian curator and lead singer of Sweet Honey in the Rock, viewed the imitation and co-opting of African-American style as inevitable, but drew the moral line at the

exchange of money. Like Ralph Ellison before her, she was willing to consider appropriations of black style by whites (whether in dance, music, or dress) as a kind of unintended compliment—but only as long as they weren't making a profit from it. Once that line is crossed, the argument went, compliment becomes robbery and legitimate rage ensues.

As for the cases we had presented for discussion at that meeting (which concerned the use of designs from other cultures on commercial bookjackets), the group wanted answers to a series of questions before deciding where they stood. How closely did the "copies" imitate the "originals"? What acknowledgments were there of the sources? What profit was gained by the copies and whom did it go to? What was the relationship between the original artist and the borrower? What was the relationship between the artist's culture and that of the borrower? What was the distribution of power and information among the players? And ultimately, did the artistic imitation drown out the original voice?

Refilling our glasses again, we began tossing around the proposition that writers confront a similar tangle of moral issues, that they must constantly conjure with the inequalities of power and knowledge between themselves and their subjects, whether they're creating a newspaper article, an anthropological monograph, or a work of fiction. Janet Malcolm's brash *New Yorker* assertion that what the journalist does is "morally indefensible," that "he is a kind of confidence man" who inevitably "betrays" his subjects, might not have upset her colleagues so much had there not been something to it. And some of the published response to her claim, which Professor Hertzman kindly passed on to us after the Princeton seminar, helped us realize the extent to which writing about one's personal experience (which is what all writers do, at greater or lesser remove) involves accepting moral re-

sponsibility. The commentary he sent us quoted Joan Didion's remark about being "so physically small, so temperamentally unobtrusive, and so neurotically inarticulate that people tend to forget that my presence runs counter to their best interests." "And it always does," she insisted. "That is one last thing to remember: *writers are always selling somebody out.*"

In those same pages, Lawrence Weschler cited a passage he'd recently written about an experience in Uruguay.

> I was interviewing General Hugo Medina, the former junta head who was now the defense minister. He said that sometimes when they were interrogating people during the military dictatorship, they would do so "energetically." And I said "energetically?" . . . He was silent for a moment, his smile steady. For him, this was clearly a game of cat and mouse. His smile horrified me, but presently I realized I'd begun smiling back (it seemed clear the interview had reached a crisis: either I was going to smile back, showing that I was the sort of man who understood these things or the interview was going to be abruptly over). So I smiled, and now I was doubly horrified that I was smiling. I'm sure he realized this, because he now smiled all the more, precisely at the way he'd gotten me to smile and how obviously horrified I was to be doing so. He swallowed me whole.

Weschler comments: "But, of course, when I write, 'He swallowed me whole,' I swallow *him* whole. So I have the last word. I get to have the Cheshire-cat grin."

Where did this leave us?

In the morning we stopped by Awali's compound with our stack of photos, which had grown to more than a hundred. Sitting on little stools under the cashew tree, we went through them one by one, trying to elicit comments that might help identify their sources. Occasionally he'd call on Selina or one of the men carving stools in the nearby shed to refresh his memory. Within the atelier, his work for Lafontaine had clearly been public.

He identified as his own a number of objects that he had denied making the day before. For some minor pieces his silences and troubled looks might have stemmed from the difficulty of stretching his memory back to insignificant commissions he'd undertaken years earlier. But much of the time he must have been simply feeling us out. As he talked, we wondered how much he might be taking credit for pieces that other Saramakas had made—his rivalry with Konfa was visceral, and he often made it clear that he saw himself as the premier carver in Equatoria.

Before saying whether or not he'd made a particular piece, he often asked what Tambou had told us, and many of his comments failed to conform to a yes/no format. Once in a while he would simply conclude that a particular piece looked "a lot like" something he'd once carved for Tambou. We realized what a shock we must have, in all innocence, given Awali the previous year when we opened the door to the museum annex, revealing Lafontaine's collection. And how unsuccessful we had been in reading his reactions.

Selina adopted a discreetly cautionary role, occasionally nudging her husband or whispering something cryptic to him to make sure he intended to be telling us as much as he was. Over and over, Awali paged through our art book and the one by Hurault, pointing out objects and motifs Tambou had asked him to copy.

Sometimes he caught resemblances that we hadn't noticed between the snapshots and the book illustrations. He showed us, for example, that one of Peronnette's trays (115) had been modeled directly on Hurault's Plate XVI (19) and another on Hurault's Plate XVII. But he said he didn't think he had ever been asked to copy illustrations directly out of our own book. As we discovered more and more matches and talked about them with Awali, it became clear that illustrations from our book always passed through the intermediate stage of a sketch or paper model by Lafontaine before being presented for copying.

Once in a while, Awali told us, Tambou let him be the one to suggest designs for particular objects. He pointed out, for example, how one of the "antique" trays in Peronnette's house had been modeled on a modern table top he'd made years earlier. In carving the tray, he had followed one of the photos in the thick album/portfolio that he kept as a catalogue of models for tourists.

After a mid-morning meal served by Selina, Awali expressed interest in looking at the original set of musical instruments that the museum had purchased from Lafontaine. Our discussions had made him eager to see the results of the piecework he'd been doing over the past few years and to understand the economics of the larger operation.

It had always been clear to us that, as part of earning his living by carving, Awali was an astute businessman, engaging in calculations concerning production, prices, and the market on a daily basis. We had always viewed this side of Saramaka carving in the context of the need that any professional artist, from Rembrandt to Rauschenberg, had to deal with money matters. But we also recognized that some Western art authorities tend to deny this privilege to "primitive" artists, arguing that once they begin making art for sale rather than

for "native consumption" their products are no longer "authentic."
No wonder, then, that one response Africans have had to the international art market's growing appetite for their material culture has been to follow up on the fabrication and artificial aging of, for example, a mask, by staging a "village ritual," captured on videotape, to authenticate it as an object intended for local ritual use.

Like artists in many societies, Awali had never harbored any illusion that art was incompatible with profit. Nor, as a Saramaka, had he tended to think about artistic copying as a moral issue—this in contrast to historical and ritual knowledge, which for Saramakas do constitute a collective patrimony that must be fiercely guarded against appropriation by outsiders. When Awali carves for his wives and himself, he does it according to his own aesthetic taste, but when he's working commercially, he calculates his time, his material, and his labor costs as a businessman. And he's willing to make pretty much anything his customers request, as long as he is fairly compensated. In his relationship with Tambou he had always felt that this had been the case.

Once we arrived in the annex, Awali began by carefully examining the two banjos. He told us he had made each of their parts except the calabash-shaped soundboxes, the fiber ties, and the bone discs on some of the tuning pegs. When we mentioned that museum documentation identified the heads on these instruments as "monkey skin," he chuckled and confirmed our earlier guess that they had been made, as most drums are too, with deerskin. He told us that at one time or another he had made all the wooden pieces of the third "banjo," as well as the violoncellos and their bows, but that Tambou or someone else

must have installed the turtle carapaces, the stingray spines, the bone discs, and the horsehair.

The three of us marveled at how pieced together and worked over the instruments turned out to be: metal wires had been inserted to strengthen connections, removable carved pegs embellished the bows, and even the soundboxes were composite. Awali had another observation that made him laugh. "Did it ever strike you," he asked, like Sherlock Holmes addressing Watson, "that if wood goes from light to dark, it passes through a middle shade? Interesting that these objects are either dark or light, but not a single one is in the process of darkening!"

Awali remembered making most of the harp's pieces, including the base it sat on, but didn't think he had made the top of the soundbox that attached to the armadillo shell. He took quite a while examining the harp's round-seated stool, shaking his head in amazement. Over the course of time, and interspersed with many other commissions, he had made every single part of it—except, of course, the bone inlays that Lafontaine had worked into the seat. But he'd never had any reason to expect that those particular pieces would be put together to form a whole. That was why the edges came together so imperfectly, he commented. We were amused to remember that Awali's name had first come up in our visit with Lafontaine when he confided to us that it was Awali who had carved the wooden pegs used to "repair" the base of this same stool.

The contents of one shelf of the annex had been earmarked for an upcoming exhibit entitled "Masterpieces of the Museum of Equatoria," and there we found the banjo and side-horn that had reminded us of eighteenth-century artifacts collected by Stedman. The other horn

was lying next to a nearly empty container of guava yogurt in the restoration room. Two of its three keys had fallen out and were awaiting reinsertion and a renewal of their glue. Awali said he had made the two side-horns, though Tambou had insisted on doing the piercing himself and was apparently responsible for adding the bone keys and fiber ties. He also had a vivid memory of the day Tambou gave him orders to leave the surfaces rough.

"Wouldn't they be nicer with a sanded finish?" Awali had suggested.

"Maybe so," Tambou had replied, "but it's not worth bothering with. I'm going to burn these horns anyway after you're done."

"Burn?" Awali thought maybe he hadn't heard right. They often had misunderstandings because of the linguistic compromises they had to make with each other. They'd both been doing their best to speak patois. He thought he had heard Tambou say *brilé*. But maybe it was some French word he didn't know.

"What did you say you were going to do?"

"*Brûler.* I'm going to use my blowtorch on them."

"Why would you do that?"

"To make them old."

For Awali, this was food for thought. Saramakas tend to view the development of art as a kind of evolution: the passage of time results in progress, late-twentieth-century artists are more skillful than their grandparents were, and physical deterioration over time reduces an object's value. For Saramakas, age in itself carries no intrinsic value. What value does inhere in older objects derives from their social and historical associations, their function as repositories of particular sentimental and historical memories. Awali was aware, in part from his experience of bringing an occasional woodcarving from Saramaka to

Cayenne for sale, that whitefolks placed a special premium on age. But this was the first time he'd heard of mechanically inducing it.

On the way to the annex, Awali had told us that each of his jobs for Tambou had, in his estimation, been fairly compensated, if you figured it on the basis of the time it had taken. After examining the instruments, we mentioned that the museum had paid Lafontaine twenty-five million centimes for them.

He let out a whistle. After a few moments he declared that, if he wasn't adding wrong, all the money he had been paid by Tambou over the last dozen years would not add up to a tenth of that figure.

"The next time Tambou comes by," he said with a smile, "I think I'll let him know that my prices have gone up."

Over lunch, we drew up a list of the objects Awali said he had made for Lafontaine. In Peronnette's collection, he had made the paddle, the two winged trays, and the stool, as well as the laundry beater, the *apinti* drum, two other trays, and even much of the cassava mill. Indeed, the paddle and cassava mill were such successes in his compound that he'd decided to make a copy of the paddle for his own use in Saramaka, and Selina had gotten him to make a smaller version of the mill for her to work with in her village back home. Madame Charrière's winged tray and spoon were also his handiwork, from three or four years earlier, he guessed. And he'd carved the two combs and the "Indian" ladle we had seen in the Balisiers apartment, which Lafontaine had told us came from Matto Grosso.

Of the large number of objects we'd examined with Awali in the museum annex the year before, we now had only a partial set of

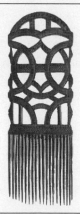

photos to serve as mnemonics for our discussions. But Awali's hand was clearly everywhere. He had carved most of the pieces that eventually were combined on the beautiful but ethnographically confused canoe prow. He had made all the instruments' tuning pegs (some of them commissioned individually, at different times). Although he said he hadn't known at the time what he was carving, he now recognized the wooden parts of the mandolins, and marveled at how they'd later been integrated with the carapaces, bone pieces, and strings. There were even a few objects for which he had been the one to fit pieces together. On Tambou's instructions, he had put the wooden mouthpieces and bell extensions onto the water-buffalo horns, the conch shell, and the armadillo tail, an item that Tambou told him he'd brought back from Brazil.

As for the objects we had imagined in a Sara Creek snake-god shrine, which Lafontaine claimed came from the mining engineer Monsieur Breton, Awali had made most of them too. For the little door (5), he said, Tambou had directed him to combine two objects from a single page of our art book (61, 98). The head and handle of the cassava rake had been commissioned separately. Never having been told they were going to be put together, Awali had had no opportunity to protest the erroneous placement of the handle. He had made both the face of the mask and its two ear panels on the basis of drawings, brought in months apart. Later Tambou had returned with the face and requested a revision in the shape of the mouth. As for the giant phallus, Awali had to admit, with a giggle, that it too was his handiwork.

A number of these objects were quite beautiful. Leaving aside ethical considerations and issues of cultural appropriation, we realized that Lafontaine had successfully served as midwife to a distinctive,

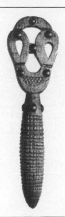

visually interesting variant of Saramaka art. And the process didn't
end there. The second paddle that Awali had made after Lafontaine's
tracing of one in *Africains de Guyane* was now back in his Saramaka
village, where other Saramaka carvers were presumably doing their
own variations on it.

On the way to our final meeting with the museum director, we
allowed ourselves to wonder whether we should be afraid. Was it
possible that Lafontaine was on to our investigation? Might Awali be
reporting back to him? We couldn't afford to believe these things if
we wanted to continue probing, but the uncertainties remained. We
also entertained the possibility that we could be endangering Awali. If
his word provided the central evidence about the operation, might
Lafontaine try to silence him? But then, tallying up a list of all the
carvers who had participated, as well as other Saramakas who were
aware of what was going on and could provide testimony—and real-
izing that Lafontaine knew how many of them there were—we felt we
could safely lay that concern, at least, to rest. Others were less easily
dismissed. Several times, a wave of fear had washed over Sally and
we'd had to take a few minutes to reason it away. Sometimes it would
happen at night, and she would wake up in a sweat. Manolo's story
about the deranged priest sometimes came back. But we didn't want
to be paranoid.

We brought the director up to date, without revealing too many
details, on what we'd been discovering. Describing Lafontaine's un-
usual piecework approach, we told her we'd never heard of a "forger"
who operated in that fashion. But we also made it clear that we were

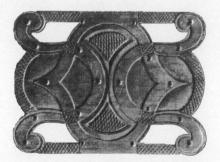

still following up a number of leads and expected to be able, over the coming days, to pin down more specific information about many of the pieces in Lafontaine's collection. In any case, we said, the "antique" instruments she had bought the year before were of recent fabrication.

She gave us a little speech about how the credibility of the museum, and of her own career as well, depended on the correct handling of this information. Indeed, in the wake of the financial scandals in the Regional Council, a decision had been made just the day before that everyone responsible for a budget under the Council's umbrella, which included her, would be required to swear a legally binding oath regarding the management of funds. This new level of accountability, she said, effectively disallowed the option of her being aware of forgeries and not taking action.

The director offered that she knew people who could help her bring discreet pressure by making inquiries into Lafontaine's tax returns (on which he was supposed to report the profit from sales he had made) and the tax declarations of the friends to whom he'd sold objects (who were supposed to list those assets). This would enhance her bargaining position should she decide to press him, on the basis of an arcane French law, to accept a quiet swap of the instruments and the 250,000 francs, a kind of annulment of the sale.

Sally asked what kind of statement she had from Lafontaine regarding the age and provenance of the objects he had sold to the museum. The director pulled out a dossier and showed us a typed page describing the pieces and summarizing the story about the Paramaribo source. Rich noticed that there was no signature. The director admitted she should have gotten him to sign his story—which she had had typed up on the basis of his oral version—but made light of it, claiming

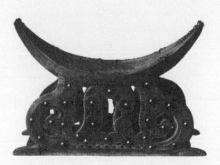

that it wouldn't be hard to find some ruse to get his signature on a piece of paper. That reminded her, she laughed, of an "authentication" that Lafontaine had recently provided for some Amerindian objects he wanted to sell to another museum in Cayenne, which hinged on his willingness to assert that he had smuggled them out of Brazil.

Attached to the typed page was her 1990 proposal, addressed to the Regional Council and the Directorate of French Museums, requesting 250,000 francs for the acquisition of the instruments and 50,000 for a professional appraisal of them. In an earlier meeting she had hastened to tell us that the appraisal money had never come through, but Sally now asked again just to be sure, commenting on how strange it seemed that the granting agencies would be willing to shell out that kind of money without requiring some assurance of authenticity. The director shrugged and assured us that she'd never received those funds.

In that same dossier we noticed our original fax from Stanford. Our four-sentence opinion of the instruments had been highlighted in yellow, and we couldn't help wondering whether it hadn't been called into service to fulfill the government's appraisal requirement.

What we were telling the director was probably close to the last thing in the world she wanted to hear. Her latest plan for the museum had visitors passing through the Amerindian and Maroon sections, and then mounting an impressive ramp to the museum's upper level, where they would be greeted by an instrument from the "eighteenth-century Creole orchestra," master emblem for an exhibition area devoted to "La Culture Créole." Hardly the place for an object whose pedigree had been called into question.

Our meeting ended inconclusively. The director said she would inform herself, once summer vacation was over, about her room for

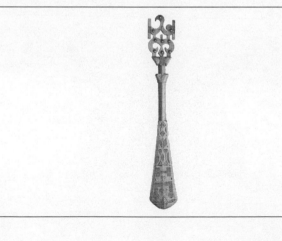

maneuver, by consulting with higher-ups in France. She thought there might be a law against de-accessioning, but didn't know how it articulated with the swap procedure she'd already mentioned. As we left, she handed us a letter from Holland addressed to us in care of her office, and promised to call us in Martinique when she had news.

We didn't entertain high hopes. Forgers, we had learned, have the deck stacked very much in their favor. People who have bought from them are seldom eager to press charges, not only because of the potential financial devaluation of their collections, but even more because of the embarrassment of exposing the fallibility of their own judgment. In a world founded on trust in the experts, an art dealer or museum director who participates in a court case risks suspicion and taint. As one authority put it, "You don't want to rock the market. Faith in the market is a very delicate thing." And forgers, savvy about the workings of this system, avoid making the kinds of claims that could convict them in court. Lafontaine had never signed any statement documenting his stories about the "Creole orchestra," just as de Hory had made sure never to dash off his artists' signatures in front of the "two witnesses" whose testimony, under French law, could have sent him to jail. One result is that the museums of the world are filled with art forgeries that the authorities have preferred not to question.

As we walked back to the car we bumped into Monsieur Peronnette. He told us he had decided to return to France and would be winding up his various business affairs in Equatoria over the coming year or two. "It's been thirty years already," he said. He was intending to sell his whole collection at the prices he had originally paid Lafontaine, and asked whether we knew anyone in Equatoria who might be interested. He'd had a devil of a time trying to export the pieces

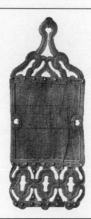

because of constant hassling by the Director of Antiquities, "a fanatic about protecting the cultural patrimony."

In the car we opened the letter, from an art historian friend in the Netherlands with whom we had shared some aspects of our investigation. It offered various comments and bibliographical tips but ended with some sobering advice: "You need to be concerned about your safety. This is a very dangerous world, where murders happen. So please don't take any chances. Even if you think you have your guy pegged, there might be someone else around who doesn't like the idea of his talking to you."

In the evening, as we finished off our bottle of Scotch, we played a kind of parlor game. With photos and books spread across the bed, the goal was to see how many more of the pieces in Lafontaine's collection we could trace to published models.

Rich scored the first points by figuring out that the arrow-and-pinwheel motif on the mask and phallus also appeared next to the figure with exposed genitals in one of Peronnette's trays (90)—and that they all exactly matched Figure 110 in *Africains de Guyane,* where they were said to be masculine and feminine symbols.

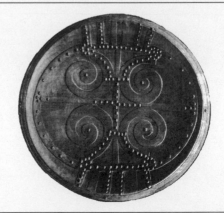

Sally got on the scoreboard by realizing that the rest of the carving on that tray was modeled on the door depicted in Figure 142 of our own *Afro-American Arts* (59).

Rich then wondered aloud whether any model for a Saramaka mask other than the one we'd illustrated had ever been published. We couldn't think of any. Opening our book to Figure 240 (117), we set down the photo of Lafontaine's mask (101) and saw for the first time how very close they were: the overall shape, the contours of the nose, the semicircular ears, the animal-hair eyebrows and mustache, and the distinctive mouth—the one Awali had been asked to redo to get just right.

With the photo still out on the bed, Sally started thinking about the versatile role of vegetable pods in Lafontaine's collection. Staring at the mask in front of her with newly opened eyes, she saw that its string-and-pod beard was not just reminiscent of the "pubic hair" on the phallus, but an absolutely perfect match. Identical in the length of their string supports, the size and color of their pods, and the degree of discoloration on their fiber ties, these two evocations of body hair must have once been a single pair of anklets, shaking rhythmically on the right and left legs of an Amerindian or Maroon dancer.

As we brainstormed further, Rich thought of another object for which there was only one possible model. As far as we knew, Hurault provided the sole depiction of a decoratively carved canoe gunwale in the whole published literature. Turning to page 66 of *Africains de Guyane,* and comparing it to the photo of the gunwale we'd seen in the annex (107), he confirmed his hunch—Awali had been hired to execute a 1950s Aluku motif on a panel that Lafontaine then affixed to a Saramaka-style canoe.

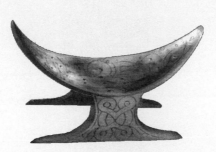

In the end, Sally won a come-from-behind victory by venturing beyond the woodcarving chapter of our book. As she worked through the pages devoted to the African legacy in Maroon art, her eye was caught by the detail of an eighteenth-century Akan throne (32), which the art historian Robert Farris Thompson had once compared to the handle of a Saramaka peanut-grinding board, but which we had argued bore no historical relationship. Its curves were identical, Sally announced triumphantly, to those of the massive winged tray we'd seen in Monsieur Peronnette's living room (79). We realized that Lafontaine, skipping over the illustration's (English) caption that gave the throne's provenance, had been so taken with the design of this African carving that he had transferred its lines to the piece of paper Awali had told us he'd been asked to copy. In fact, as it turned out, that same African model had found yet another incarnation when Awali carved Madame Charrière's *pièce de résistance* (118).

Our last full day in Equatoria. Despite some severe apprehensions on Sally's part, we called Lafontaine to say we would come to say goodbye the next morning, before we left for the airport. Meanwhile, we paid a courtesy visit to the director, spent some time with Awali and Selina, walked around the large open market, wrote some final notes, packed, and went to bed.

Sally found herself in a dimly lit room. She could make out the

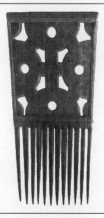

shapes of the canoe prow and other artifacts spread all about, but wasn't sure whether it was the museum annex or Lafontaine's apartment. She tried to ask Rich, but he was off at the edges, sleuthing. She could hear noises that seemed to be coming from another part of the building. Then approaching footsteps and the doorknob turning. Sally ducked behind a sofa, whispering to Rich to do the same. But he was scraping away at a corroded tack and obstinately refused to stop. Sally pleaded with him, crying desperately. He insisted that he was busy with something and couldn't be interrupted. In walked Lafontaine, brandishing a gun. Sally woke up, shaking.

In a groggy, post-dream state, Sally's mind raced on binary opposites that seemed all of a piece—figure/ground, authentic/fake, original/copy, conner/conned, stalker/stalked, male/female, seducer/seduced. As she regained lucidity, the logic fell apart. But the disequilibrating effect of the dream stayed on. Who was chasing whom? Who was conning whom? Who knew what the other was up to?

On our way to Les Balisiers, we tried to hold our fear in check. We couldn't be sure that he wasn't on to us. How could we know he wasn't setting us up?

Down the spiral staircase and into the stuffy living room. No Elgar this time, and no request to close our eyes. We were hosted with another bottle of Alsatian wine and shown another antique trunk filled with feathered extravaganzas. We waited for Lafontaine to confirm our fears, but it was just more of the same. He fished for compliments on his Maroon collection, and expressed anxiety about his upcoming European trip.

He also told us that "any day now" he was expecting a gigantic meter-and-a-half-long water-buffalo trumpet, more fantastic than any-

thing we'd yet seen, from the gentleman in Paramaribo. Might we be interested in seeing it on our next trip to Equatoria?

Later that year a colloquium on the situation of illegal immigrants brought us again to Cayenne. When we paid our customary visit to the compound behind Awali's carving shed, we learned that it had been several months since he'd seen Lafontaine. But two days later, as we were getting dressed to go to a session on diet in the refugee camps, there was a knock at the door of our hotel room. Awali's face was expressionless but his tone was solemn. Lafontaine was dead—the heart attack he'd been predicting. Awali's nephew had heard the death announcements on the radio that morning, and Awali thought we'd want to know. We attended the funeral the next afternoon.

We never really managed to get Lafontaine out of our heads. The following year, during a visit to São Paulo, Rich thought he saw him in a crowd, pushing his way through a vast street market. Sally suggested a drink to cool down his overheated imagination. The next time she was the one, in the Miami airport, who spotted a diminutive figure in a Hawaiian shirt getting on a bus just as it pulled away.

Could we both be going out of our minds? Why would a man want to stage his own funeral? We speculated that Lafontaine had the connections and means to do it—friends in the police, a doctor whose complicity could have been bought, Brazilian associates who could have helped him over the border without a trace. But what would have been the motive? Drug trafficking? Arms smuggling? Pretty much anything was possible—even something to do with the antiquities

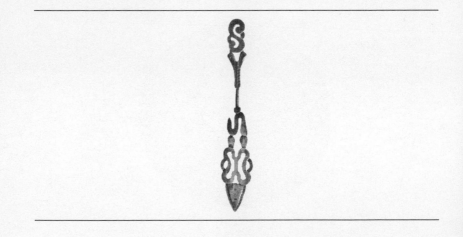

trade in carvings or feathers. Or was it rather that life in the tropics was finally beginning to rot out our brains?

But a few months later, in Bahia, where we were participating in an Afro-Brazilian *congreso* on race relations, it was both of us who saw the third man. This time he was wearing a straw hat and shades, sitting in a café near the beach, looking as though he was staring across the street directly at us. Retreating around a corner, we waited until he had paid his bill and then began trailing him from a distance, winding around pedestrians, hanging back whenever he turned in our direction. We lost him almost three hours later near the Pelourinho, when he slipped into the maze of streets behind the Igreja São Francisco.

NOTES

ILLUSTRATION SOURCES

ACKNOWLEDGMENTS

NOTES

Notes are keyed by page number.

iii. The music on the title page is the first violin part for the opening of Edward Elgar's *Enigma Variations* (Op. 36). We are also indebted to that score for our dedication.

1. J. Tripot, *La Guyane: au pays de l'or, des forçats et des peaux-rouges* (Paris: Plon, 1910), p. 277.

1. Alfred Métraux, *Itinéraires 1 (1935–1953): carnets de notes et journaux de voyage* (Paris: Payot, 1978), pp. 191–192 (diary entries for 28–30 May 1947).

2. Louis Doucet, *Vous avez dit Guyane?* (Paris: Denoël, 1981), pp. 102–105.

3. Lafcadio Hearn, *Two Years in the French West Indies* (1890; New York: Harper and Bros., 1923), pp. 1, 64–65.

12. The ceremonial speech was made by Joël Joly, president of ARDEC, reported in *France-Guyane* in 1989; the exact date is missing from our copy of the clipping.

12. SEMAGU, "Programme Technique Détaillé" (Cayenne, September 1988), pp. 5–7.

22. The lithograph is labeled "A Scene in Dutch Guiana in 1826. Benjamin Farre del et Lithog. 1840. Printed by C. Hullemandel." Collection of Silvia W. de Groot.

22. The essay on connoisseurship was published in Sally Price, *Primitive Art in Civilized Places* (Chicago: University of Chicago Press, 1989), pp. 7–22.

23. Lord Kenneth Clark's statement is in his *Another Part of the Wood: A Self-Portrait* (London: John Murray, 1974), p. 45.

23. See, for example, Thomas Hoving, *King of the Confessors* (New York: Ballantine Books, 1982).

23. The English professor seems to have been drawing on James Brooke, "Ivory Coast: Faced with a Shrinking Supply of Authentic Art, African Dealers Peddle the Illusion," *New York Times*, Sunday, April 17, 1988, section 2, p. 47.

38. Michel Laclotte, Chief Curator of Paintings at the Musée du Louvre, is twice quoted thus, on pp. 28 and 36 of F.D.-R., "Qui décide de l'authenticité des tableaux?" *Connaissance des Arts* no. 407, January 1986, pp. 27–39.

60. The writer's assessment comes from Léon-Gontran Damas, *Retour de Guyane* (Paris: José Corti, 1938), p. 45; the journalist's from Alexander Miles, *Devil's Island: Colony of the Damned* (Berkeley: Ten Speed Press, 1988), p. 2.

70. Professor Swann's exposition follows closely Carlo Ginzburg, "Clues: Roots of an Evidential Paradigm," in his *Clues, Myths, and the Historical Method* (Baltimore: Johns Hopkins University Press, 1989), pp. 96–125.

72. Ms. Kim's reference is to Bill Holm, *Northwest Coast Indian Art: An Analysis of Form* (Seattle: University of Washington Press, 1965), p. 82.

72. With all due respect for Professor Randall's erudition and insight, we would point out that he was a bit overhasty in chiding Carlo Ginzburg for sloppy acknowledgments. Ginzburg's 1989 *Clues, Myths, and the Historical Method*—Professor Swann's source for the essay in question—dutifully records its publication history in both Italian and English, as do the versions in *History Workshop* (1980) and in the book that Professor Randall calls *The Rule of Three* (actually, *The Sign of Three*, which Sebeok edited in 1983 with Umberto Eco).

73. The German professor's etymological discussion is modeled on p. 23 of Nicolas Barker, "Textual Forgery," in Mark Jones, ed., *Fake? The Art of Deception* (Berkeley: University of California Press, 1990), pp. 22–27.

73. Anthony Grafton's lectures were published as *Forgers and Critics: Creativity and Duplicity in Western Scholarship* (Princeton: Princeton University Press, 1990). The comments Professor Briggs alludes to can be found on pp. 45–49 and 65–67. And the classic treatise he refers to is J. B. Mencke's *On the Charlatanry of the Learned*.

74. Professor Hertzman's reference is to Clifford Irving, *Fake! The Story of Elmyr de Hory, the Greatest Art Forger of Our Time* (New York: McGraw-Hill, 1969).

76. Professor Vanderkunst's main source on Han van Meegeren seems to have been Lord Kilbracken, *Van Meegeren: Master Forger* (New York: Charles Scribner's Sons, 1967).

78. Professor Dixon-Hunt's clipping was John Russell's "As Long as Men Make Art, The Artful Fake Will Be with Us," *New York Times*, Sunday, February 12, 1984, section 2, pp. 1, 24).

79. The British Museum exhibition was accompanied by the catalogue *Fake? The Art of Deception*, edited by Mark Jones (Berkeley: University of California Press, 1990). Palmer Wright's citations appear on pages 15 and 240. Bredius's original comments appeared in *Burlington Magazine*, November 1937.

84. Grafton, *Forgers and Critics*, p. 6.

84. The article in the dentist's office was Alicia Mundy, "The Artful Forger,"
 Gentlemen's Quarterly, June 1992, pp. 200–206, 214–217.
85. The "JM" literature is vast, but for starters, see Martin Gottlieb, "Dan-
 gerous Liaisons: Journalists and Their Sources," *Columbia Journalism
 Review,* July-August 1989, pp. 21–35; and Janet Malcolm, "The Moral-
 ity of Journalism," *New York Review of Books,* March 1, 1990, pp. 19–
 23; as well as a series of *New York Times* reports on the Malcolm-Mas-
 son trial during the spring of 1993. The "zigs and zags" remark comes
 from Jane Gross, "At Writer's Libel Trial, the Focus Turns to Styles of
 Speaking," *New York Times,* May 19, 1993, p. A8. The "sex, women,
 and fun" paragraph follows David Margolick, "Libel Suit Uncovers Raw
 Nerve: Quotations," *New York Times,* October 5, 1990, p. B8.
87. On the Peg Goldberg affair, see Dan Hofstadter, "Annals of the Antiq-
 uities Trade: The Angel on Her Shoulder," *New Yorker,* July 13, 1992,
 pp. 36–65, and July 20, 1992, pp. 38–65.
87. Background to the Cellini cup discussion can be found in Joseph Alsop, "The
 Faker's Art," *New York Review of Books,* October 23, 1986, pp. 25–31.
90. The Vayson de Pradenne volume was published in Paris in 1932 by Emile
 Nourry. We quote from pages 8–9, 585–586, 593–596, and 674.
93. The dictionaries we drew on were *Le Petit Robert 1* (Paris: Dictionnaires
 Le Robert, 1990), *Robert Collins Dictionnaire Français-Anglais Anglais-
 Français* (Paris: Dictionnaires Le Robert, 1987), the *Oxford English
 Dictionary* (New York: Oxford University Press, 1971), and the *Random
 House College Dictionary* (New York: Random House, 1984).
108. For more on Chavenet see William Gaddis, *The Recognitions* (New York:
 Harcourt Brace, 1955)—Chavenet first comes up on p. 558 of the 1993
 Penguin paperback.
110. Elgar's ideas for the ballet are reported in Michael Kennedy, *Portrait of
 Elgar* (London: Oxford University Press, 1968), p. 70.
133. We have taken Boggs's story from "Is It Counterfeit Money or Art? (Or
 Can It Be Both?)," *New York Times,* December 6, 1992, p. 17, and from
 p. 20 of David Lowenthal, "Forging the Past," in Jones, ed., *Fake? The
 Art of Deception,* pp. 16–22.
135. Gombrich spells out his argument in *Art and Illusion: A Study in the
 Psychology of Pictorial Representation* (London: Phaidon, 1959); Welles
 makes his observation in his 1975 film *F for Fake.*
138. The pages Professor Hertzman gave us were a set of interviews by Martin
 Gottlieb in the *Columbia Journalism Review,* "Dangerous Liaisons: Jour-
 nalists and Their Sources," July-August 1989, pp. 21-35.
149. Our discussion of things that discourage the prosecution of art forgers
 draws on Orson Welles's *F for Fake;* a 1973 Minneapolis Museum of
 Fine Arts catalogue called *Fakes and Forgeries,* by Kathryn C. Johnson;
 Eric Hebborn's autobiography, *Drawn to Trouble: The Forging of an
 Artist* (Edinburgh: Mainstream Publishing, 1991); and the book by Clif-
 ford Irving that Professor Hertzman had read.

ILLUSTRATION SOURCES

In designing the pixelated ornaments for the pages of this book, we applied computer manipulations to images from various published and unpublished works, frequently combining them with one another. For documentation, we refer readers to the following publications; numbers in parentheses refer to pages of *Enigma Variations*.

Ernesto Cavour Aramayo, *El charango: su vida, costumbres y desventuras* (La Paz: Cima, 1988): p. 156 (52).

Philip J. C. Dark, *Bush Negro Art: An African Art in the Americas* (London: Tiranti, 1954): Plates 1b (136), 18c (9), 21a-detail (105), 27a (81), 27b (84), 34b (143), 36 (39), and 42c (114).

Jean Hurault, *Africains de Guyane: la vie matérielle et l'art des Noirs Réfugiés de Guyane* (Paris and The Hague: Mouton, 1970): Plates VIII/2 (129), IX (51), XI/1 (127), XI/2 (78), XI/3 (128), XII/1 (28), XIV (86), XVI (19), XVIII/1-detail (57), XVIII/3-detail (14), and XVIII/5-detail (108).

Morton C. Kahn, *Djuka: The Bush Negroes of Dutch Guiana* (New York: Viking, 1931): pp. 27/204 (81) and facing p. 196 (96).

Sally Price and Richard Price, *Afro-American Arts of the Suriname Rain Forest* (Berkeley: University of California Press, 1980): Figures 36a (153), 49h (38), 122a (7), 122b (8), 122e (92), 122f (35), 122g (56), 122h (95), 123a (36), 124a (126), 124b (122), 125b (154), 126 (18), 127a (134), 129 (33), 130a (88), 131 (149), 132 (130), 133 (116), 134b (148), 136a (23), 138c-detail (74), 138d-detail (75), 140 (110), 142 (59), 143 (65), 146 (138), 149 (77), 150b (145), 151 (131), 153 (103), 154 (47), 155 (44), 156 (42), 165a (61), 165b (98), 166 (133), 168 (82), 169 (26, 76), 173 (64), 175 (54, 80), 177 (2, 34), 178 (62, 71), 179a-detail (109), 189a (152), 189b (144), 189c (63), 189d (15), 193 (17, 91), 194 (43), 195 (48, 124), 197 (137), 200 (21), 201c-detail (30), 202a-detail (58), 202c-detail (100), 204a (94), 205 (3), 206 (125), 208 (142), 209a (121), 240 (117), 243 (72), 246 (41), 249 (31), 250 (22), 252

(99), 265a-detail (32), 267 (147), 269a-detail (11), and Plates XV (6, 85) and XVI (68).

Corinna Raddatz, ed., *Afrika in Amerika* (Hamburg: Hamburgisches Museum für Völkerkunde, 1992): p. 169 (135).

Additional models for our graphics were kindly provided by: the Museum voor Volkenkunde Rotterdam—photos of two Saramaka masks, collected for the Surinaams Museum in 1968 "from Asini, Upper Suriname River" (49, 155); the American Museum of Natural History—a Ndjuka foodstirrer, collected ca. 1930 (120); the Bureau du Patrimoine Ethnologique, Cayenne—a Saramaka peanut-grinding board carved by Mando for the future museum in 1990 (119); Kathryn Burns—a *charango* purchased in Peru in 1982 (66); and Bonno and Ineke Thoden van Velzen—a Ndjuka tray, carved at the beginning of the century and collected in the village of Puketi in 1961 (106).

Seven illustration graphics are modeled on postcards (dated 1986) from the Völkerkundemuseum, Herrnhut, Germany (132, 139, 140, 141, 146, 150, 151).

Two graphics are modeled on previously unpublished pieces from our own collection: a Saramaka stool carved by Gonima, village of Asindoopo, ca. 1960 (25), and an early-twentieth-century Saramaka comb given us in 1981 by Dianne Nevel of Burbank, California, about which we have no further information (67).

Documentation for all other illustrations is included in the text.

ACKNOWLEDGMENTS

During the course of this project we benefited from fellowships (one to each of us) from the John Simon Guggenheim Memorial Foundation, a research grant from the National Endowment for the Humanities, a Rockefeller Humanities Fellowship at the University of Florida, and two grants-in-aid from the Wenner-Gren Foundation for Anthropological Research.

For helpful comments on drafts of the manuscript, we are grateful to Jim Clifford, Bill Germano, George Lamming, Leah Price, Niko Price, Peter Redfield, Gary Schwartz, and Randy Starn. We also thank Camille Smith of Harvard University Press for her sensitivity in the final manuscript editing.

For stimulating discussions of the story as it was unfolding, we are grateful to Ilisa Barbash, Antonio Díaz-Royo, Patrick Menget, Gert Oostindie, Dan Rose, William C. Sturtevant, and Lucien Taylor. Special thanks to Scott Parris for providing Elgar lore.

The computer graphics were produced while we were guests of the Center for Latin American Studies at the University of Florida, Gainesville, and, later, serving as George A. Miller Endowment Visiting Professors at the University of Illinois, Urbana-Champaign. We are grateful to those universities for the use of their computer labs, where we spent countless hours using scanners and Photofinish software.